ESPAÇO ABERTO/ESPAÇO FECHADO

SITES FOR SCULPTURE IN MODERN BRAZIL

HENRY MOORE INSTITUTE

2006

With essays by Stephen Feeke, Michael Asbury, Cacilda Teixeira da Costa and Felipe Chaimovich
Texts by artists in the exhibition
Additional contributions by Regina Teixeira de Barros

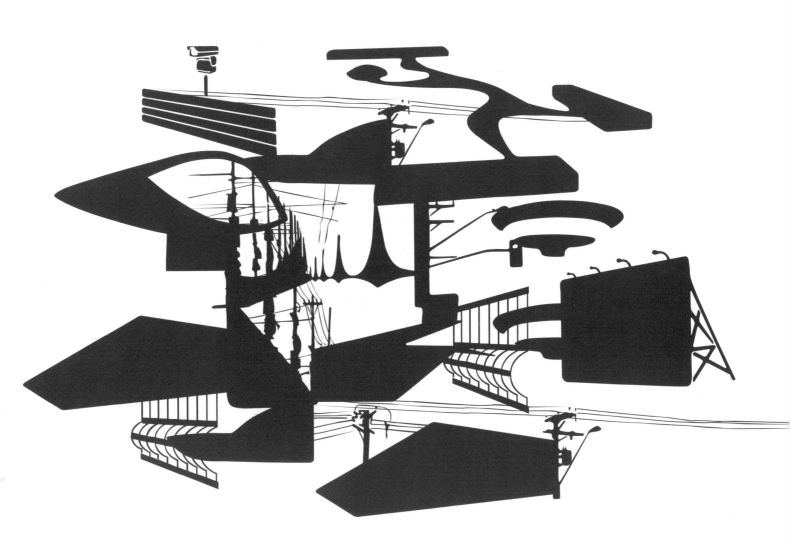

Artur Barrio

Max Bill

Victor Brecheret

Rogério Canella

Paulo Climachauska

Waldemar Cordeiro

Detanico Lain

Antonio Dias

Ducha

Grupo Gallery Rex

Grupo 3nós3

Jac Leirner

Antonio Manuel

Cildo Meireles

Luisa Lambri

Jarbas Lopes

Rubens Mano

Iran do Espírito Santo

Eduardo Srur and Fernando Huck

Franz Weissmann

CONTENTS

Preface:
Pavement and pavilion

IN THE WORK of the Henry Moore Institute we have to make sense of our role as a centre for the study of sculpture at the same time as developing the scope of our exhibition programme. As we have expanded its temporal range, we have been conscious of needing similarly to expand its geographical reach. Making a show about Brazil makes sense for us as a first step, given that Europe and North America have been parameters for a Brazilian art which has been shaped in relation to these referents. Many of our recent exhibitions – from *Wonder* to *Taking Positions* – have examined how sculpture reflects the place and the time in which it is made, and the present show runs very much in that vein.

As the locus of a modernism which is both recognisable to the European eye and different – shaped by different materials, a different climate, and different requirements – Brazil has come to exercise an increasing fascination. The longevity of Oscar Niemeyer – who, even more than Aalto in Finland represents both a modern and a national style – renders the modernist tradition in Brazil at once curiously young and oddly old. At the current time in Europe and America architectural bookshops are full of books on Brazilian modernism, and young European artists are increasingly drawn to its sites. Brazilian modernism seems to represent an essential purity as well as a hybrid vernacular; the continued possibility of life for an ideal which has been more quickly abandoned in our own country.

Among our curatorial team Stephen Feeke has been particularly keen to develop the range of the Institute's programme, which he initially extended by working with The British Museum on a series of shows which went under the collective title of 'Object Cultures'. Having identified an interest in Brazilian sculpture, we had to find the framework for a show which made sense for the Institute, and the dialogues which Brazil opens up within modernism – with its new and old centres, its new and old generations, its arriving and departing artists – made this possible. In particular, I should like to note three moments which helped me, at least, fashion an understanding. One was seeing, in Paul Andriesse's Amsterdam gallery, Luisa Lambri's recent photographs of Niemeyer's architecture and in particular his Casa das Canoas. Another was the edition of the Canadian magazine *Parachute* which, in an issue devoted to the last São Paulo Bienal, made evident how sculpture asserted its place on the public highway during the 1970s. The third was one of several useful discussions with Michael Asbury, in which he highlighted the fact that the awards for sculpture at the first São Paulo Bienal in 1951 – made to Max Bill and also to Victor Brecheret – brings home the duality of the Brazilian artistic heritage.

The Institute has additionally been able to take advantage of the fact that we could time our exhibition to coincide with the tour organised by our colleagues in Perry Green of *Henry Moore: Uma Retrospectiva* in São Paulo, Rio de Janeiro and Brasília. The subject of Moore in Brazil reflects very neatly a key aspect of our exhibition here: the hybrid nature of modernism and its changing legacy.

Stephen Feeke's visit to São Paulo was very ably and generously facilitated by Regina Teixeira de Barros and I am grateful to Marcelo Araujo, Director of the Pinacoteca do Estado for allowing Regina to give so much of her time to our project, particularly when she was preparing the Moore show and its catalogue. In addition, I would like to thank Lucia de Meira Lima of the Paço Imperial for acting as Stephen's guide to Rio de Janeiro and for arranging visits to many of the artists who are based there and also to Lauro Cavalcanti, Director of Paço, for making it possible

for Lucia to offer so much help. During his time in Brazil Stephen was able to meet almost all the artists who are now in the exhibition; we are greatly indebted to them for responding to his invitation to show, and to write, with such enthusiasm. Special thanks are due to Franz Weissmann's family for continuing to help us during the difficult time after his death in 2005.

With his customary careful and dedicated planning Stephen has brought to Leeds almost every sculpture which he set out to find or to borrow and conceived an elegant framework in which to show three very different moments from the larger story of Brazilian sculpture over the last 50 years. None of them, however, is isolated, for a defining notion of this show is that of borrowing and exchange between artists of different ages and across different locations. Stephen's choice of a title – borrowed from Rubens Mano's photo of Niemeyer's Bienal pavilion – which reflects the importance of sculpture as a currency both inside and out, in official spaces and in unofficial interventions, amplifies the thrust of a small show with larger implications. It has been specifically designed to complement the better-known activities of the Neoconcrete artists which have been comparatively widely shown in Europe over the last few years, and which are on show again in *Tropicália* at the Barbican Art Gallery which coincides with our own show. As Stephen explains in his introduction, the notion of *Espaço Aberto/Espaço Fechado* hints at the potential of the unfilled space, and this show looks at sculpture as an object which is formed by the way in which it circulates.

PENELOPE CURTIS
Curator
Henry Moore Institute

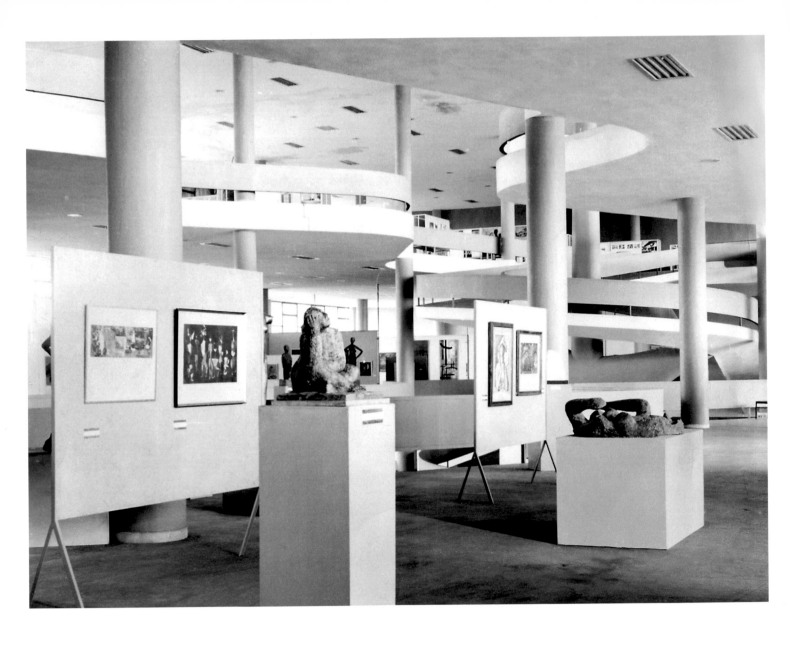

FIG 1: Installation view of the 4th Bienal de São Paulo, 1957 in the pavilion designed by Oscar Niemeyer

Introduction

CAT 31: Rubens Mano's 'Visor' at the 2004 Sydney Biennial

THE TITLE of this exhibition, *Espaço Aberto/Espaço Fechado*, is taken from a photographic work by Rubens Mano (b. 1960). Looking into the photograph (cat. 4), we are taken into an enormous room that seems all openness and space. The wide vista is punctuated by columns, which converge on a vanishing point that seems to disappear into a hazy white void. Otherwise the space is empty except for the flood of natural light from windows to the left and right. Even though there are few details to help give us a sense of scale, the proportions seem rather odd. Although it is long and wide, the space is not very high, and so the room feels as if it is compressed between a low ceiling and the dark grey floor. What is portrayed here is a kind of contradiction: a space that could be infinite and yet is bound by its architecture. We see a room that looks vast and full of light and air, but which also seems gloomy and confined. It is a space that is both open and closed.

The building captured in the photograph was designed in 1951 by a team headed by Oscar Niemeyer (b. 1907), as part of an overall complex in Ibirapuera Park, São Paulo. Since 1957 it has housed the São Paulo Bienal (it is formally named after the Bienal's founder, Francisco 'Ciccillio' Matarazzo Sobrinho).[1] Few people, however, will ever have the chance to see the building in such an empty state, since it is more usually full of the paraphernalia of all kinds of exhibitions as well as visitors (fig. 1). Mano offers us a glimpse of a kind of 'impossible' place that can only be encountered through photography.[2] Without a display, the space is physically empty but full of potential.[3]

Rubens Mano, who works in many media, often explores the ways in which we shape and control the urban environment by challenging the systems and boundaries that make us feel safe. Since much of what is actually around us is overlooked, he draws our attention to our surroundings by skewing our vision of what we take for granted. 'Visor', 2004 (originally made for the Sydney Biennial and recreated here for this exhibition, cat. 31) for instance, consists of bottles containing opaque plastic masks and which are handed out to people on the street. Outside of the gallery space and with no explanation that they are involved in an artwork, people are offered a chance to experience the world differently. Putting on the mask almost obliterates the wearers' world into a mish-mash of colours and shapes. Removing it restores their focus.

Together these two works reflect on the places where it is possible to encounter art, from the formality of a specially designed building to the informality of 'everyday' space. As such they introduce the main theme of this exhibition, which is a consideration of the sites that have been used for displaying sculpture in Brazil. Set against a background of fluctuating social, political and economic stability over the last fifty years, the exhibition takes key works from key moments to explore why some of the most important sculptors in Brazil not only experimented with different kinds of media but also with alternative places to show their work. As we shall see, in the 1960s and 70s, sculptors took their work onto the streets to circumvent the restrictions of an increasingly harsh regime. Further experimentation into the public domain proved that, notionally, the location of a work could be anywhere and sculpture proved the perfect idiom for this kind of invention. Sculptors working today retain this dynamism, supported by re-invigorated commercial galleries and the return to democracy.

1 The first venue was the Trianon (since demolished and now the site of Museu de Arte de São Paulo). The second Bienal was held in Niemeyer's Pavilions of the States and the Nations in Ibirapuera Park, but the inauguration was delayed until December 1953 so that it continued into 1954 and coincided with the 400-year anniversary of the founding of São Paulo (hence it is sometimes called the 1954 Bienal).

2 J. Wood, *Close Encounters: The Sculptor's Studio in the Age of the Camera*, Leeds; Henry Moore Institute, 2001, p. 14.

3 Special thanks to Ana Magalhães for showing me round the empty pavilion.

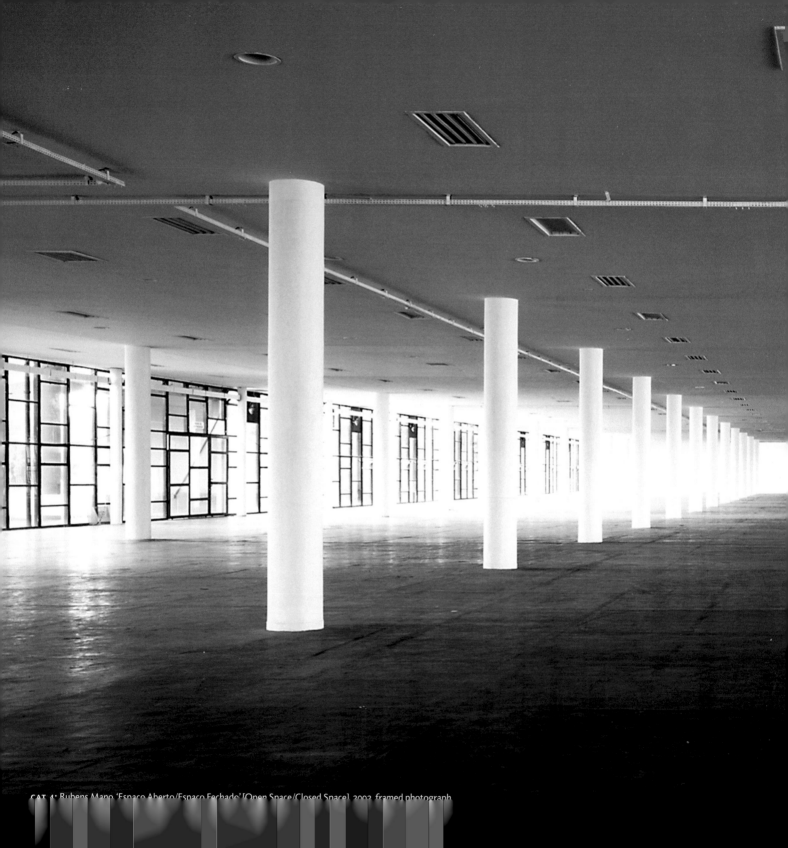

CAT 4: Rubens Mano 'Espaço Aberto/Espaço Fechado' [Open Space/Closed Space] 2002 framed photograph

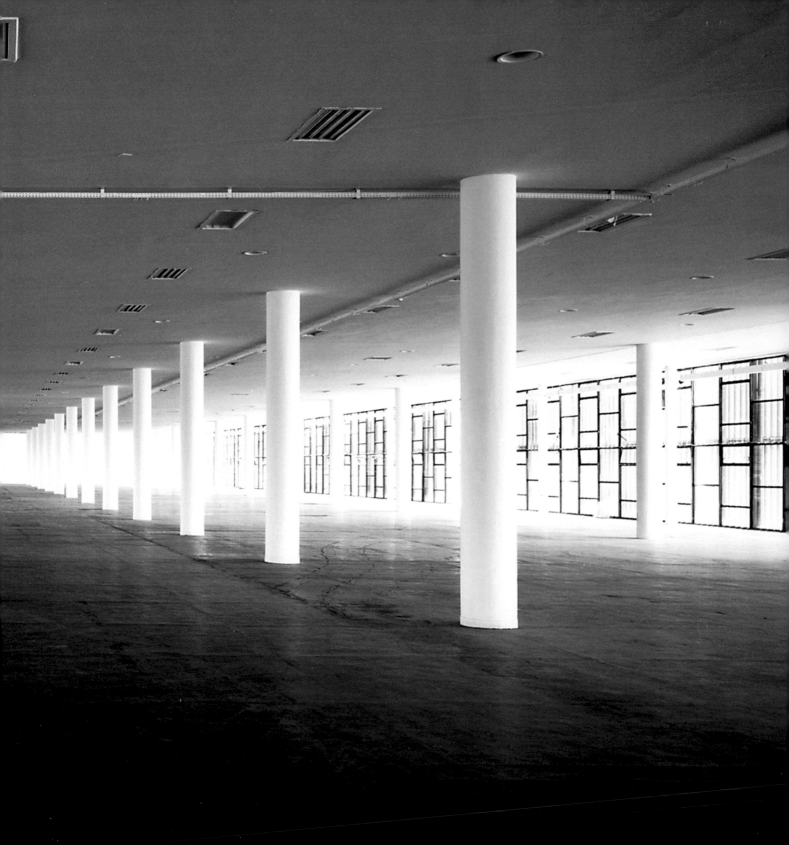

1: CLOSED SPACE

The first section of the exhibition continues the re-examination of Niemeyer's pavilion, with other recent works made by contemporary artists, which, alongside that by Rubens Mano, respond directly to the architecture of the building. Together these works highlight some of the criticisms of Niemeyer's style of architecture. However, they also are testament to the fact that the architect – who continues to design major projects today – has maintained an enduring fascination throughout a long career and that he remains of interest to a generation of artists working today.

In 'Untitled (Palácio da Indústria #03)' (cat. 7), Luisa Lambri (b. 1969) has concentrated on the distinctive pavilion windows.[4] The back grid of the metal window frames forms a threshold where inside and outside meet and almost merge with the trees in Ibirapuera Park pressing keenly against the glass. Indeed, São Paulo is a tropical city and growing amongst all the white and grey concrete are peculiarly green trees and plants. As Lambri's photograph suggests, there is a sense that nature could reclaim São Paulo despite the continuing urban sprawl, the pollution, the traffic and the vast population.

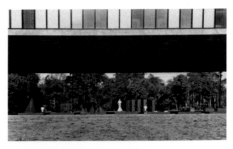

FIG 2: Nelson Leirner's 'Playground I' and 'Playground II' exhibitions beneath the Museu de Arte de São Paulo and Museu de Arte Moderna do Rio de Janeiro in 1969

Interestingly, the windows were not part of Niemeyer's original plan for the ground floor, which was intended to be completely open. Since the pavilion was first intended for industrial displays and not for art, this would have been helpful logistically. It would also have created a freely accessible exhibition area below the elevated main body of the pavilion, which is characteristic of several buildings (especially museums) from this period (fig. 2). However, it would have also meant the space was difficult to secure, especially since visitors would have been expected to pay for admission. Niemeyer's expansive use of glass was therefore a compromise. It enclosed the space and delineated the boundary with the outside world. Importantly, the glass allowed in the light, which symbolised the Modernist precepts of openness and democracy.

Although Modernism decreed that form should follow function, we can see in 'Bienal #1 & 2', 2004 (cat. 5) by Rogério Canella (b. 1973) that Niemeyer was prone to grandiose statements and to 'photogenic' architecture.[5] The central system of ramps connects the different levels in the pavilion, but also has great sculptural presence. The ramp can indeed dominate the space and compete with the actual exhibits. It is perhaps therefore wise to work literally with the actual architecture of the building or even emulate it, as projects by Mike Nelson and Paulo Climachauska have recently done (figs. 3 & 4).

In the 1950s it still seemed possible that modernist architecture could generate new and better social conditions. In reality, it is doubtful Modernism proved so egalitarian and in fact it was capitalism that built Brazil.[6] Paulo Climachauska (b. 1962) uses a reductive method of drawing which refers to the emphasis on accumulation (which obviously still prevails in society today). Climachauska builds up an image, for example of the Niemeyer pavilion (cat. 6), by drawing a series of ever descending numbers instead of drawing a line. Through this subtraction, he reconsiders the possibility of a 'balance between art, society and life'.[7] The graphic design 'Utopia' (cat. 8) by Detanico Lain (Angela Detanico, b. 1974 and Rafael Lain, b. 1973) also explores the limitations of the Modernist dream and how impossible it has proved to beautify an industrial urban environment; cities – especially in Brazil it seems – are simply too big, too varied and chaotic.

4 Lambri, who is Italian, spent three months in Brazil photographing buildings designed by Niemeyer and Lina Bo Bardi (architect of the Museu de Arte de São Paulo).

5 M. Bill, 'Architect, Architecture and Society', lecture given on 9 June 1953 at São Paulo University published in P. Andreas & I. Flagge (eds), *Oscar Niemeyer: A Legend of Modernism*, (exhibition catalogue), Frankfurt am Main; Deutsches Architektur Museum, 2003, p. 119.

6 P. S. Duarte, *The 60s: Transformations of art in Brazil*, (exhibition catalogue), Rio de Janeiro; Campos Gerais, 1998, p. 25.

7 P. van Cauteren, 'Drowning by numbers', published in the catalogue of the *26a Bienal de São Paulo: representações nacionais*, São Paulo; Fundação Bienal, 2004, p. 91.

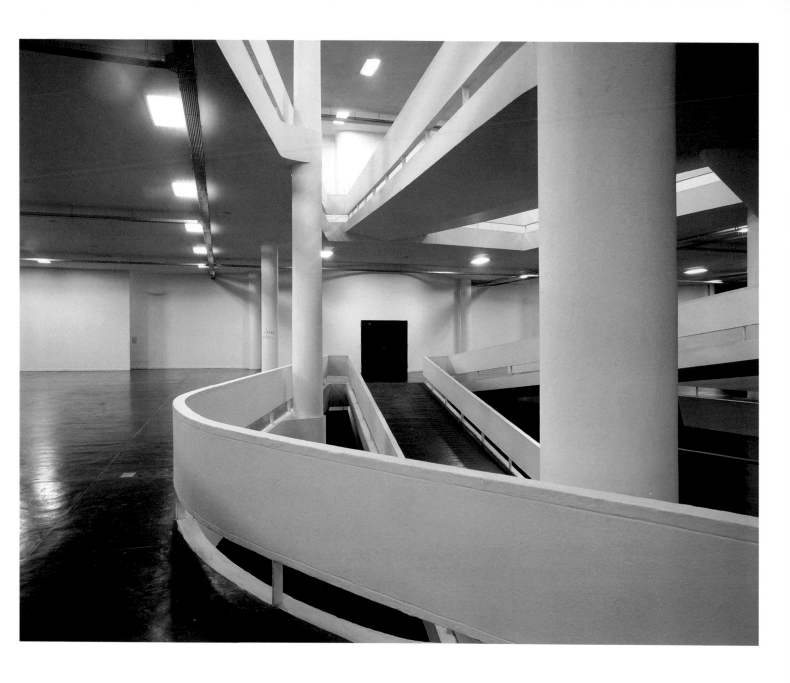

FIG 3: Mike Nelson's 'Modernismo Negro' (architectural intervention: constructed curved wall in the style of Oscar Niemeyer, mezzanine floor, spiral staircase and mechanised drum pedal) at the 26th Bienal de São Paulo in 2004

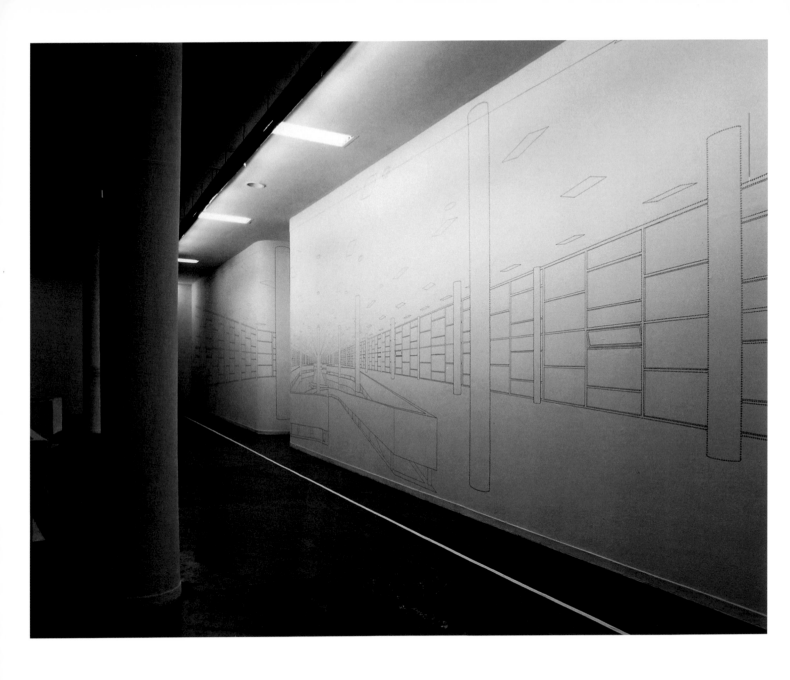

FIG 4: Paulo Climachauska's 'Palácio', 2004 at the 26th Bienal de São Paulo

The contemporary works exhibited here surround three key sculptures from the 1950s. 'The Indian and the Fallow Deer', 1950 (cat. 2) by Victor Brecheret (1894–1955) and 'Tripartite Unity', 1948 (cat. 1) by Max Bill (1908-1994) were exhibited at the first São Paulo Bienal in 1951 and respectively won awards for National and International sculpture. Despite being officially sanctioned by the Bienal, by 1951 Brecheret largely represented the figurative past of Brazilian sculpture. His award was probably more an acknowledgement of the once dominant figuration that was being superseded by the abstraction which was arguably 'the common denominator of all the countries represented' at the 1st Bienal.[8] The third sculpture shown here, 'Emptied Cube', 1951 (cat. 3) by Franz Weissmann (1911–2005), was rejected for exhibition by the Bienal panel. Whilst the Swiss-born Bill has often been credited with introducing Concretism to Brazil, in fact his award in 1951 'only confirmed a path that Weissmann (amongst others) had already begun to tread'.[9] Shown together now, these three works illustrate the move from the figurative tradition of Brecheret to the abstraction of Bill and Weissmann. They also represent the dialogue between the National and the International, which accelerated developments in Brazilian modern art.

The juxtaposition of works shown at the first Bienal with more recent works which respond to Niemeyer and the Bienal pavilion in this section of the exhibition, is meant to convey a sense of the optimism of 1950s Brazil. International attention was drawn to Brazil, to the Bienal, to the music, film and poetry, but especially to Niemeyer. Even now, his designs seem to symbolise best the confidence and ambition of the country. Whilst his influence is assessed by the current generation of artists in the show – some more critically than others – in the 1950s, his reformist ideology promised a utopian vision that still seemed attainable (fig. 5). The period of prosperity also encouraged innovations in sculpture through abstract geometry. Sculptors galvanised themselves into groups centred in São Paulo and Rio de Janeiro, finding a way forward in the theories of Concretism which eschewed subjective elements and artistic expression in favour of universality, reason, order and progress. By the end of the 1950s, however, experiments by Weissmann (amongst others) moved away from such rigorous objectivity and explored a more 'expressive space' through Neoconcretism.[10]

2: MAKING SPACE

The military coup of 1964 was followed by twenty-one years of dictatorship. Increasingly harsh, especially in the late 1960s and 70s, the new regime took control of all aspects of everyday life. Censorship, imprisonment, torture, exile were just some of the methods employed to silence any kind of opposition. Many artists, like Lygia Clark, Hélio Oiticia and Antonio Dias, felt compelled to leave Brazil to establish their careers and sought 'exile' in Europe. In 1966 Antonio Dias was offered funding from the French Government but it still took him 6 months and R $400 to buy illegally a passport that would allow him to travel to Paris. Whilst there, he found Europe too was in political turmoil. The uprisings in Paris of May 1968 used the slogan 'It is forbidden to forbid', which had resonance in Brazil, especially when the 'AI-5' law, banning all political opposition, was passed.[11] However, in comparison to Brazil, European instability was more exciting than perilous which meant it was possible for Dias to make works like 'To the Police', 1968 (cat. 19), in protest against injustices in both Europe and Brazil. His work from this period also contains a sense of

CAT 19: Antonio Dias, 'To the Police', 1968, bronze with metal tags

8 Bienal Judge Santa Rosa interviewed by Yvonne Jean in the newspaper *Correio da manhã*, 23 October 1951, from the archives of the Fundação Bienal de São Paulo, (translated by Juliet Attwater).

9 R. Roels Jr., 'Franz Weissmann: uma retrospectiva 1951-1998' in *Franz Weissmann: uma retrospectiva*, (exhibition catalogue), Rio de Janeiro; Centro Cultural do Banco do Brasil and Museu de Arte Moderna & Sao Paulo; Museu de Arte Moderna, 1998, p. 222, (translated by William Gallagher).

10 Weissmann signed the 'Manifesto Neoconcreto' along with Ferreira Gullar, Amilcar de Castro, Lygia Clark, Lygia Pape, Theon Spanudis and Raynaldo Jardim. It was first published in the *Jornal do Brasil* (Rio de Janeiro) on 22 March 1959.

11 In September 1968, Caetano Veloso was booed whilst singing *É Proibid Proibir* [It is Forbidden to Forbid] during the elimination rounds of the International Song Festival in São Paulo. After the Fifth Institutional Act (AI-5) was passed in December the same year, both Caetano and fellow singer/activist Gilberto Gil were arrested and imprisoned. See 'É Proibid Proibir' in *Tropicália*, (exhibition catalogue), São Paulo; Cosac Naify Edições, in association with the Museum of Contemporary Art, Chicago, The Bronx Museum of the Arts, New York and GabineteCultura, São Paulo, 2005, p. 244.

longing for a better place. In 'Anywhere is my land', 1968 (cat. 17), that place could be somewhere amongst the stars. (Outer space had gripped the world's imagination since the 'space race' was at its peak – the first moon landing was in 1969 – but stars also figure in the Brazilian flag, so Dias may have been thinking of home). With 'Do it Yourself: Freedom Territory', 1968 (cat. 20), Dias' attention was more earthly, in which he suggests that both a safe zone and a work of art could be made at ground level by anyone, anywhere.

In reaction to increasing restrictions imposed by the military regime, there was an upsurge in creativity amongst the artists who stayed in Brazil. Much of the art from this period directly criticised the authorities and it should not be underestimated how difficult or dangerous this was. As we shall see in many of the works in the exhibition, however, by being imaginative or using humour, it was possible to deflect the attention of the police. Nevertheless, many of the works shown here were made at great personal risk. In order to make works in the first place, artists had to overcome the restrictions symptomatic of an authoritarian period, becoming not only more inventive in the ways they made work but also in ways of displaying it. Actually making works was difficult since opportunities were scarce; there were few official invitations or commissions. Making a living was almost impossible. Public art museums existed, but were strictly controlled by the militia who would close down exhibitions considered to be subversive.[12] Commercial art galleries existed, but the overall artistic environment was limited and provincial in comparison to the internationalism of the 1950s. Taking matters into their own hands, artists turned their attention beyond the limits of the official regime and outside of the sanctioned formality of the gallery space and literally took to the streets. They experimented with readily available materials and with different forms, to expand radically the parameters of sculpture.

Sculpture, by its very nature, could easily be sited outdoors. Artur Barrio (b. 1945), for example, took lumpen bags of bloodied debris and left them on the streets in downtown Rio. Made at the height of the dictatorship, works such as 'Unleashing confusion on the streets … situation', 1970 (cat. 9), evoke the dismembered corpses of the missing. Barrio photographed the bags and continues to show the images in a slide-show format. This gives the work an added impact, since the pictures look like reportage. During this period and right through to the early 1980s, sculptors made increasing use of actual news media in order to make work, to publicise it, and also to record it for posterity. Grupo 3NÓS3 (see cat. 10) for example, often used simple sheets of coloured plastic to dramatic effect on the busy roads of São Paulo.[13] Their ephemeral work did not last long before the traffic destroyed it or the police removed it, and without printed and televised media their temporary interventions would certainly have made less of an impression. One of the early works by 3NÓS3, 'Ensacamento', 1979, involved wrapping the heads of public monuments with plastic bags (including works by Brecheret). The resultant images are chilling evocations of military silencing, torture and murder. However, the work also symbolised a defiant break with the past and the increasing meaninglessness of traditional sculpture and public monuments. Symbolically, the unofficial interventions by 3NÓS3 made between 1979 and 1982 represented the reclamation of the streets towards the end of the dictatorship. Although the return of democracy was slow, reform in the 1980s did at least start to loosen the grip on censorship. In comparison, today there is a much greater freedom of expression. It is now possible for an artist like Ducha (b. 1977) to turn a major landmark like Cristo Redentor bright red in

CAT 10: View of 'Ensacamento' [Bagging], 1979 by 3NÓS3

12 Antonio Manuel, interview with Lúcia Carneiro and Ileana Pradilla in *Palavra do artista*, Rio de Janeiro; Lacerda Ed., 1999, p. 80.

13 3NÓS3 was formed by Mário Ramiro, Hudinilson Jr. and Rafael França (all were born in 1957, França died in 1991).

16

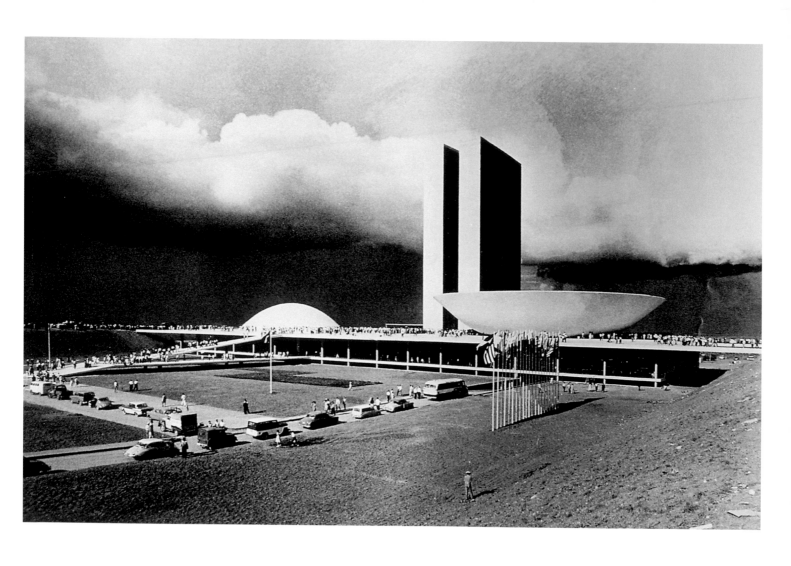

FIG 5: Thomaz Farkas' photograph of Brasília, taken c. 1960 (the inaugural year of the city as capital of Brazil)

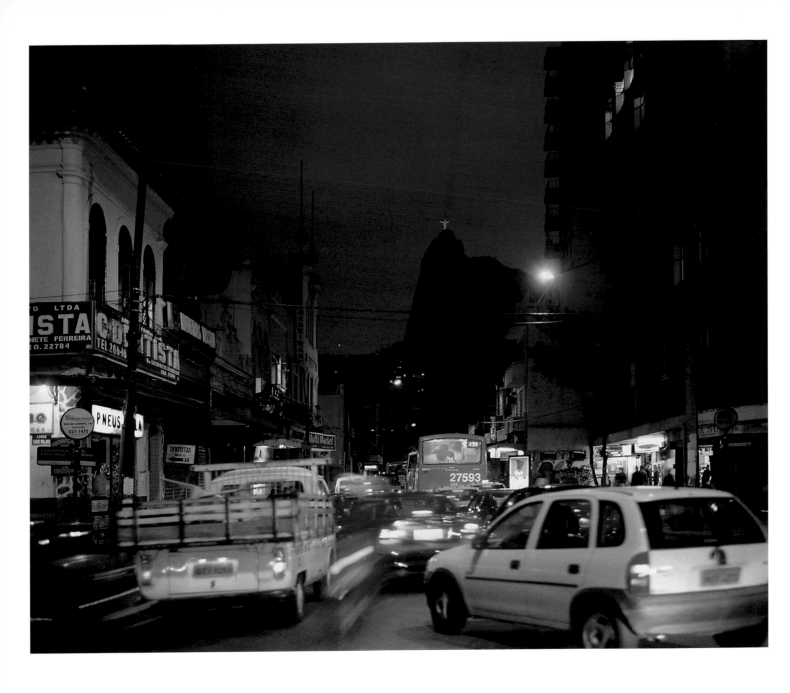

FIG 6: Ducha, 'Christ the Redeemer Project', 2001, Rio de Janeiro

his 'Christ the Redeemer Project', 2001 (fig. 6) or to create a splash of orange as in the 'Laranja' performance (cat. 11), without fear of imprisonment.

Artists' use of printed and televised media perhaps seems obvious today, but in the 1960s and 70s it marked an innovative development in the dissemination of both work and ideas in what was 'another era … a slower and more divided world'.[14] There were more substantial obstacles to circulation, not just ideologically but also technologically, geographically and politically, which globalisation has done much to eradicate. The artists of the Grupo Gallery Rex (cat. 13) tackled the isolationism of the period by opening their own gallery, organising exhibitions, events and 'happenings' and publishing their own newspaper *Rex Time*.[15] In the first edition of the paper, the 'Rexes' ran the headline 'Warning: War's Declared'. Gallery Rex & Sons lasted for a year from 1966, but despite the defiance and irreverence of their combined efforts the audience they attracted was small. However, the closing event - Nelson Leirner's *Exposição não-exposição* [Non-exhibition exhibition] – proved that there was still a public of sorts for innovative contemporary art. The organisers advertised in newspapers that visitors to the gallery would be allowed to take away any exhibit they could remove. Although the works were chained down, it was only a matter of minutes before a stampede had stripped the gallery and an impromptu auction set up on the pavement outside.

Actual newspapers figure directly in the work displayed here by Waldemar Cordeiro (1925–73) and Antonio Manuel (b. 1947), combining text and image to convey and comment on the social realities of the time. In the collage called 'Jornal', 1964 (cat. 24), Cordeiro has spliced strips of real newspaper together so that the front-page story is unintelligible to allude to the censorship of the time. Manuel made use of newspapers in a number of different ways. Often he took printing 'flans' to make work, like 'Repression once again – this is the consequence', 1968 (cat. 21), which evidences the impact of the dictatorship.[16] Newspaper stories, including the death of a student protester, are represented in bold red and black but are concealed behind canvas screens. The viewer lifts the canvas – i.e. removes the barrier of censorship – so that the horror stories shout out. Predictably, the military closed down the exhibition when the work was shown at Rio's Museu de Arte Moderna in 1969, which, ironically, ensured the exhibition had more press attention than it would have otherwise received and certainly reached a much wider audience.

Like many of his contemporaries in the late 1960s, Cildo Meireles (b. 1948) was committed to using his work to speak out against the politics of the time. Instead of newspapers, which were readily controlled by the dictatorship, he made use of other everyday items – like bank notes or Coca-Cola bottles – that were widely distributed through extant systems of circulation, to spread anonymous political statements (cats. 14–16). Such works were originally intended for an indeterminate exhibition space well beyond the confines of the gallery so that ideologically they existed only when they were in circulation. Made at a time when troops could surround a museum and close down an exhibition, the 'Insertions…' slipped through controls because they were modest interventions (even if the messages they carried were meant to be direct and inflammatory), which only slowly became instilled in the wider consciousness. Because 'Insertions…' did not fit into traditional categories, the authorities did not recognise them as art.

CAT 13: The crowd outside the 'Non-exhibition exhibition' (the closing event at Gallery Rex & Sons), São Paulo, 1967

14 P. S. Duarte, *op cit*, p. 25.

15 Nelson Leirner, Wesley Duke Lee, Geraldo de Barros, Carlos Fajardo, José Resende and Frederico Nasser established Gallery Rex.

16 Now obsolete, 'flans' were used to provide the matrices for the cylindrical surfaces of rotary printing presses.

3: OPEN SPACE

After the return to democracy in 1985, events in Brazil proved that nothing could be taken for granted. By 1990, inflation had become hyperinflation and money became almost worthless until the *Plano Real* was introduced in 1994 and replaced one monetary system with another. Jac Leirner (b.1961) has explored this financial crisis in a series of works. For example, the collage 'Lung', 1987 (fig. 7), charts the rising costs of a pack of cigarettes. Like Meireles, Leirner has also made use of actual money, but she prefers notes that have been taken out of circulation which she has a self-confessed tendency to hoard. Over a long period of time, she has collected the detritus of everyday life – items like old bank notes, receipts, business cards, plastic bags – which has been widely distributed and freely exchanged and which is loaded with connotations of life *out there*. The economic collapse of the 1980s enabled her to collect and collate innumerable banknotes, from which she made three-dimensional objects like 'Wheel' and 'All the One Hundreds' (cats. 25 & 26), works which juxtapose 'aspects of social and human reality with a loose sculptural mass'.[17] The notes Leirner used were all formerly 100,000 Cruzeiros, which in the course of the decline were each officially re-valued and re-stamped to be 100; the simple fact that she had (and still has) so many proves that they had become worthless. However, by turning them into 'art' she gives them a new status and value.

Placing an artwork in the public domain, as many of the artists in this exhibition have done, can be problematic. It is difficult to gauge responses to such interventions and the street is an uncontrollable environment where art can be attacked, maligned, misunderstood or simply ignored. However, working outdoors and outside formal constraints remains of interest to artists today. In the case of 'Drops', 1997 (cat. 12), by Iran do Espírito Santo (b.1963) it does not seem to matter that the work did not survive more than a few hours. Made originally for a cross-border art project called *InSite* in Tijuana, Mexico and San Diego, USA, cast-concrete dice were left in different locations in both cities, outdoors and in, without explanation and as if they had just been randomly 'dropped'.[18] Left in the open, the dice were soon graffitied, vandalised or stolen (despite being made of concrete). Exposed in this way, the dice emphasised the precariousness of human existence, since we are all subject to 'the roll of the dice' which governs the circumstances into which we are born. Whilst organising such external projects can prove bittersweet, at their core is the desire to provoke some kind of thoughtful reaction and to promote debate. This compulsion is much the same for Iran do Espírito Santo now as it was for the artists of Grupo Rex in the 1960s or 3NÓS3 in the 70s.

The combination of earlier and more recent works in this exhibition is not meant to suggest that there is a neat narrative in the last fifty years of Brazilian sculpture. Whilst some artists may deliberately reference the past, others resolutely distance themselves from some of the more established names known best to us in Europe.[19] However, there are still some analogies to be made between works from the previous decades and more recent examples, primarily because the works chosen for the exhibition were made in direct response to specific circumstances at certain key moments. There are formal similarities, for instance, between the strips of real newspaper in the 'Jornal' by Waldemar Cordeiro and the strips from found political posters woven together by Jarbas Lopes (b.1964) in his 'O Debate' series (cat. 29). It remains relevant for Lopes to protest about the current political situation in his work as it was for Cordeiro to comment on

17 G. Brett, *Transcontinental: Nine Latin American Artists*, (exhibition catalogue), London; Verso, Birmingham; Ikon & Manchester; Cornerhouse, 1990, p. 62.

18 The photographs are exhibited here as a record of the original work.

19 For instance, Ivo Mesquita has written about Nelson Leirner and Iran do Espírito Santo as '…alternatives to the sometimes accommodated and monolithic view that all contemporary Brazilian art is indebted to the powerful legacy of Lygia Clark and Hélio Oiticia.' See I. Mesquita, 'Nelson Leirner and Iran do Espírito Santo, Venice, 1999' published in A. Pedrosa (ed), *Nelson Leirner and Iran do Espírito Santo: 48. Biennale di Venezia – Padiglone Brasile*, São Paulo; Fundação Bienal, 1999, p. 38 (translated by Victoria Cordeiro).

FIG 7: 'Pulmão' [Lung], 1987, by Jac Leirner

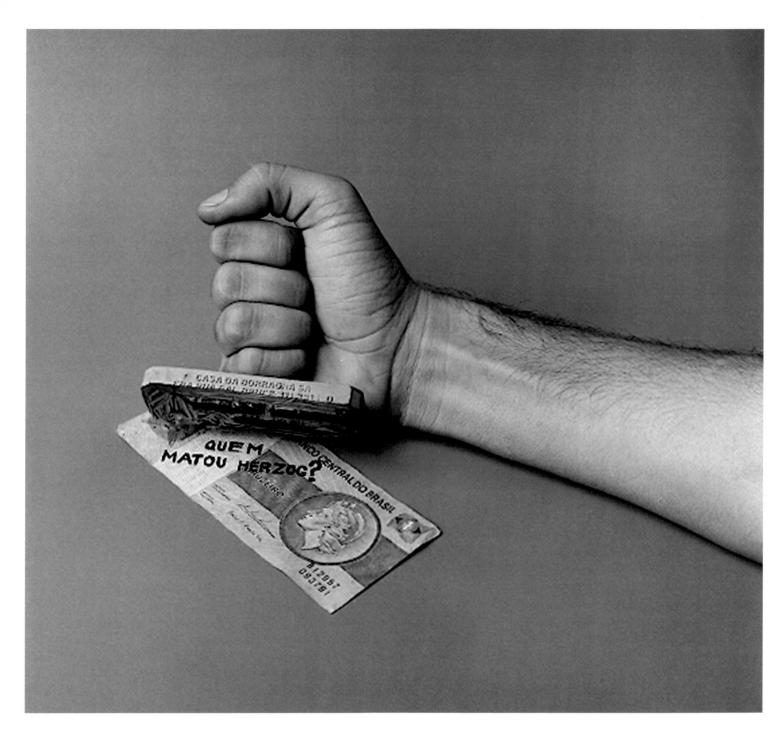

CAT 15: Inserções em Circuitos Ideológicos: Projeto Cédula [Insertions into Ideological Circuits: Banknote Project]: (Quem Matou Herzog?) [Who Killed Herzog?], rubber-stamped bank note, 1970

the censorship of the 1960s. Despite the peace and prosperity now, there is still corruption and scandal in Brazilian politics, hence the warp and weft of Lopes' works represents the ducking and diving of modern politics. But the faces of the politicians in the posters become distorted in his work, suggesting that individual politicians are largely indistinct and unrecognisable today.

The striking difference between the works made now and then is the absence of overt state control. The combination of restrictive measures that forced many artists to leave Brazil in the 1960s or 70s are no longer in place. For career reasons, some artists still feel compelled to leave Brazil, but nowadays at least they have the choice to travel at will. Debate is possible today since the freedom of expression is not constrained by censorship. For instance, Jac Leirner could draw attention to the fluctuations of the Brazilian economy without fear of imprisonment or arrest. Moreover, she could make her commentary public by exhibiting her sculptures in galleries or art museums. As we have already seen, many artists – like Ducha – still take subversive action and make work outside the formal confines of the gallery. In the case of 'Attack', 2004 (cat. 30), Eduardo Srur (b. 1974) took to the streets to carry out a 'bombing' campaign against the saturation of advertising posters in São Paulo. In his work, the media is no longer the helpful tool used to disseminate an artist's ideas, but is the focus of criticism and attack. This film, like all the works in this last section of the exhibition, references the space outside. By exhibiting it in the gallery, the film brings something of the street inside along with Srur's irreverence and humour. In this way, the film illustrates that the gallery space has become porous, a place that blends the inside with the outside and the formal with the informal. Indeed it illustrates the theme explored in this last section of the show, that the exhibition space has become more 'open'.

STEPHEN FEEKE

Artists' pages and catalogue of exhibits

Exhibited works are accompanied by texts specially commissioned or selected by the artists with additional contributions by Regina Teixeira de Barros. A few cases were drawn from previous publications (these are dated and fully cited on pp. 106–7). Dimensions of works are given as height × width × depth (cm) unless otherwise stated.

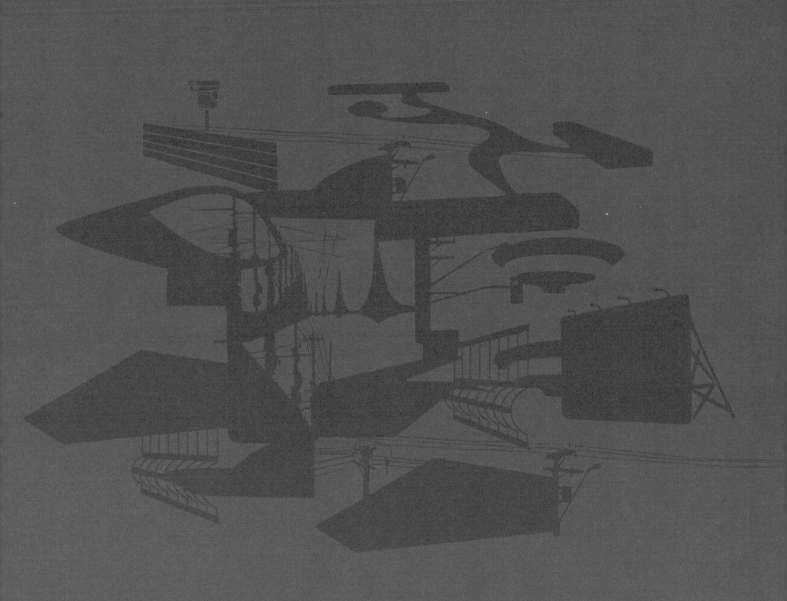

1
Max Bill
(Swiss, 1908–1994)

'Unidade Tripartida' [Tripartite Unity], 1948
Stainless steel, 114 × 88.3 × 98.2
Museu de Arte Contemporânea da Universidade de São Paulo

Max Bill: CONCRETE ART

WE CALL 'Concrete Art' works of art which are created according to a technique and laws which are entirely appropriate to them, without taking external support from experimental nature or from its transformation, that is to say, without the intervention of a process of abstraction. Concrete Art is autonomous in its specificity. It is the expression of the human spirit, destined for the human spirit, and should possess that clarity and that perfection which one expects from works of the human spirit.

It is by means of concrete painting and sculpture that those achievements which permit visual perception materialize. The instruments of this realization are colour, space, light, movement. In giving form to these elements, one creates new realities. Abstract ideas which previously existed only in the mind are made visible in a concrete form.

Concrete Art, when it is true to itself, is the pure expression of harmonious measure and law. It organizes systems and gives life to these arrangements, through the means of art. It is real and intellectual, a-naturalist while being close to nature. It tends toward the universal and yet cultivates the unique, it rejects individuality, but for the benefit of the individual.

(1936)

2
Victor Brecheret
(Brazilian, born in São Paulo 1894–1955)

'O Índio e a Suassuapara' [The Indian and the Fallow Deer], 1950
Bronze, 79.5 × 101.8 × 47.6
Museu de Arte Contemporânea da Universidade de São Paulo

Regina Teixeira de Barros: VICTOR BRECHERET

IN 1921, Mário de Andrade suggested to Brecheret that he: 'Study our different groups of native-Indians, groups not without beauty. Stylise them, unify them into a unique, original group and in this way you will have reached your greatest potential'.[1]

Nearly 30 years went by before the artist heeded the advice from Brazilian modernism's most prominent critic, which had referred, quite correctly, to the interest that primitive societies aroused in the European avant-garde, in the same way as formal simplification, a recurring theme in modern production.

The aim of modernist painters in the 1920s was to develop a visual concept for national art, one that consisted of themes which rediscovered typically Brazilian elements – whether they were native plant species, shared common traits or indigenous cultural manifestations – expressed through an innovative international language which was predominantly figurative.

Brecheret was practically the only modernist sculptor of the period. He focussed on formal investigations instead of researching possible themes of a nationalist character, until 1947 when he began the inscriptions on rounded surfaces that are reminiscent of rock art. 'O Índio e a

1 Mário de Andrade, 'Victor Brecheret'. *Jornal dos Debates, Rio de Janeiro*, 18 abr. 1921. Apud Annateresa Fabris, *O múltiplo de Brecheret*, Rio de Janeiro: Piracema, v. 3, n. 4, 1995, p. 95.

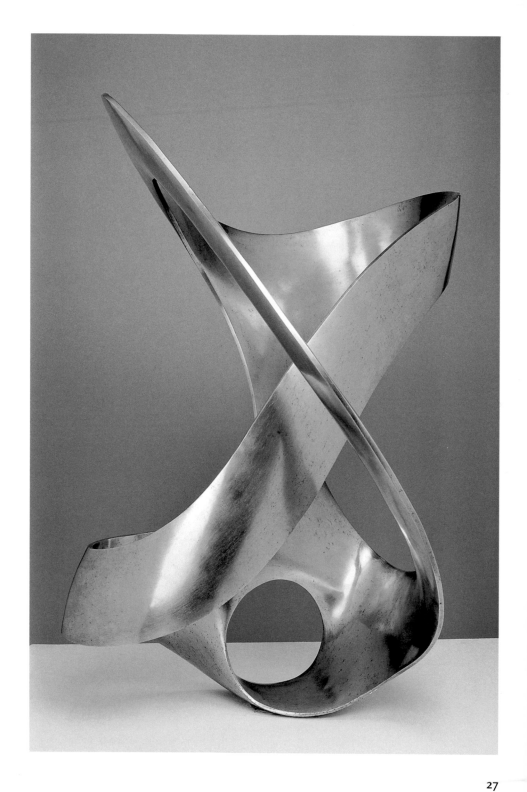

CAT 1: Max Bill, 'Unidade Tripartida' [Tripartite Unity],
stainless steel, 1948

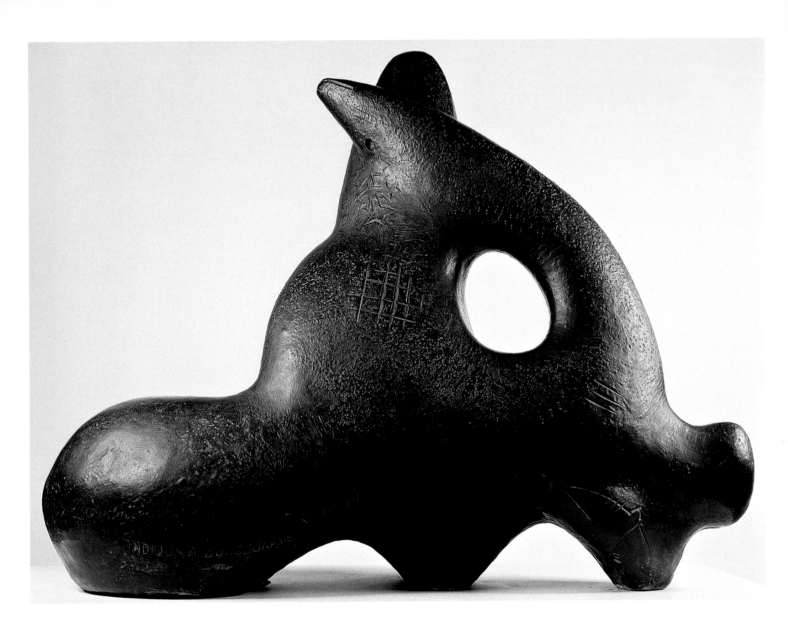

CAT 2: Victor Brecheret, 'O Índio e a Suassuapara' [The Indian and the Fallow Deer], bronze, 1950

Suassuapara' [The Indian and the Fallow Deer] is one work from this group. Its award at the I São Paulo Bienal in 1951 represented the long overdue recognition of *Modernismo* ideals.

3
Franz Weissmann

(Brazilian, born in Austria, 1911–2005)

'Cubo Vazado' [Emptied Cube], 1951 (1995)
Steel with wooden base, 75 × 64 × 64 (maximum)
Franz Weissmann Estate, Rio de Janeiro

Franz Weissmann:
I HAVE NEVER KNOWN HOW TO COPY ANYTHING, ONLY CREATE
THE 'CUBO VAZADO' [Emptied Cube] was finished in 1951 and had been designed the previous year. At the time I had never even heard of Max Bill. However, I needed to strive for a pure geometric art. So I began with the square plane which is my obsession. From this plane I progressed to the cube. However, I was still dissatisfied with the cube and so I hollowed it out, achieving an empty cube from a solid one. This work was created in Belo Horizonte [in the state of Minas Gerais] and was undertaken under the most difficult circumstances. It was a large piece, a metre wide, and made from sheets of soldered and polished brass. I submitted it for the Bienal but they refused it. That made me sick. The judges had not realized that this piece was the first radically constructivist sculpture to be created in Brazilian art. It was turned down due to the soldering marks, but no one had taken into consideration that it had not been made in Switzerland, but in Belo Horizonte.

(1995)

CAT 3: Franz Weissmann, 'Cubo Vazado' [Emptied Cube], steel with wooden base, 1951 (1995)

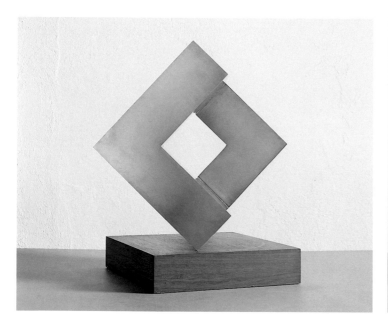
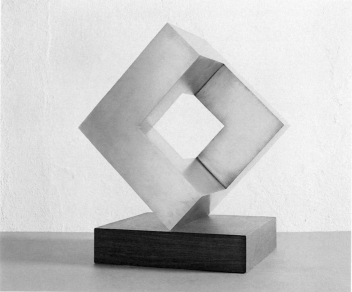

4
Rubens Mano

(Brazilian, born 1960)

'Espaço Aberto/Espaço Fechado' [Open Space/Closed Space], 2002
Framed photograph, 125 × 250
Collection of Sandra and Raphael de Cunto, São Paulo

Rubens Mano: ESPAÇO ABERTO/ESPAÇO FECHADO

THIS IMAGE taken on the second floor of the building which hosts the São Paulo Bienal shows us a rare moment in its recent history: the empty interior. Although it has been used for a long time as a space dedicated to the arts, the pavilion in Ibirapuera Park has also begun to host an increasing number of commercial fairs and events.

Built at the beginning of the '50s and conceived by Oscar Niemeyer, the architectural project was intended to be a reiteration of the Modernist utopia in that it suggested, with lightness and transparency, the quest for an effective relationship between the interior/exterior – a desirable integration between the building and its context. Its intentions are apparent in the way that it is supported on stilts and that there is a continuous glass façade.

It has been noted, however, that this 'permeability' has begun to suffer from the physicality of other structures 'constructed' within the space through the actions and practices of the institution that maintains it. In addition to the characteristics considered by the architect – which were meant to create greater flexibility – the space has increasingly started to show an institutional

CAT 4: Rubens Mano, "Espaço Aberto/Espaço Fechado" [Open Space/Closed Space], framed photograph, 2002

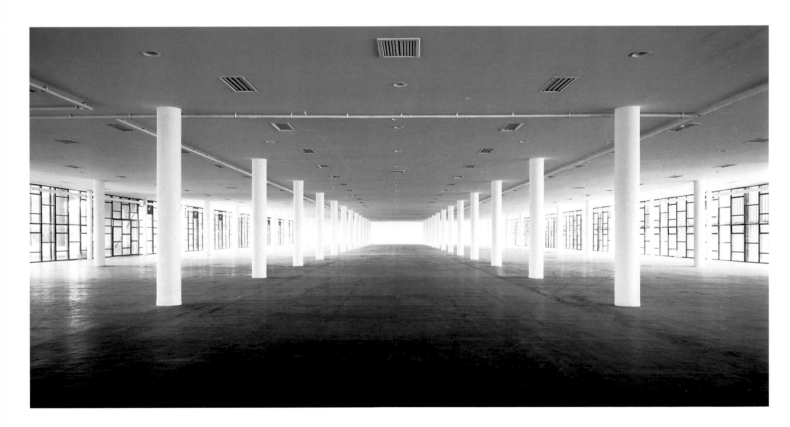

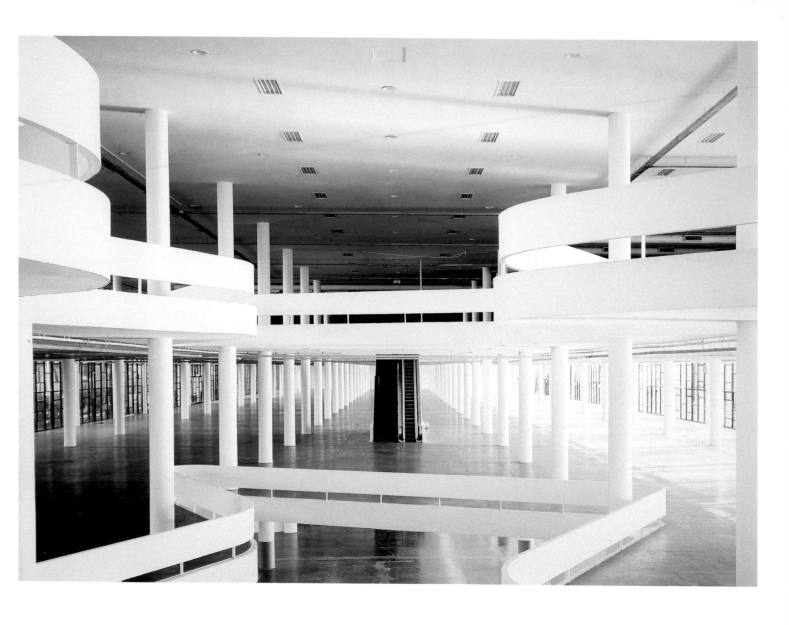

CAT 5: Rogério Canella, 'Bienal #1', photograph, 2004

31

presence; indicating how the register of forms can materialise other symbolic dimensions that can occasionally interfere with the manifestation/apprehension of certain artistic practices.

The importance of this image then, which should really only have significance for people familiar with the building, has begun to connect also with other symbolic instances associated with this modern architectural space. This can be done either by commenting on the existing correspondences between public experience and private experience, or by suggesting that the supposed *abertura* [opening] intended by the project, or a possible action capable of resignifying it, may now be experienced only through the image.

I have given this work the title 'Espaço Aberto/Espaço Fechado' [Open Space/Closed Space].

5
Rogério Canella

(Brazilian, born 1973)

CAT 5: Rogério Canella, 'Bienal #2', photograph, 2004

'Bienal #1 & 2', 2004
Photographs, 90 × 140 × 5 cm
Galeria Vermelho, São Paulo

Rogério Canella:
TIME AND ARCHITECTURE, PHOTOS FROM THE SÃO PAULO BIENAL

THE TWO IMAGES produced in the São Paulo Bienal building in 2004 show the empty pavilion at a moment between the dismantling of one event and the installation of that year's Bienal. The images don't make this situation clear, and neither, due to the absence of scale references, do they show the building's true dimensions to an observer unfamiliar with the space. However, if one pays attention to the floor of the pavilion, it is possible to see a series of footprints left by the soles of someone's shoes in the layer of dust. These traces proving the passage of an individual through this constructed space suggest that time can also, in a way, be understood through the accumulation of the dust that allows the footprints to appear.

An inherent element of photography is that the time represented in it is the passing of time, exactly that moment which, at some point, was understood as definitive and able to be represented in photography. Since the series 'Paisagem' [Landscape], the representation of time has been present in my work, whether it be in two images of separate locations that have simultaneously felt the effects of the passing of time, or in a single image that reveals the traces of human actions.

In trying to leave the passing of time 'visible' and explode the concept of photography as the portrayal of a single moment, issues are raised about the transformation and constant substitution of spaces that are considered obsolete in an urban landscape.

This idea of the extension of time through a single image may be seen as corroboration of a type of death of the concept of the photographic instant. Consequently it questions a model of modern development that has utilised photographic means for its dissemination.

The images of the Bienal building, a fully functioning structure, are a counterpoint in this production only as long as they don't allow the perception of a future obsolescence for this architectural space. However, they do allow the understanding of time, one of the variants used in the production of a photographic image. This leaves in question the kind of transformation this particular covered space will undergo. It shows only what has been recorded on film, what the shutter aperture, the other variant of photography, has allowed to be seen.

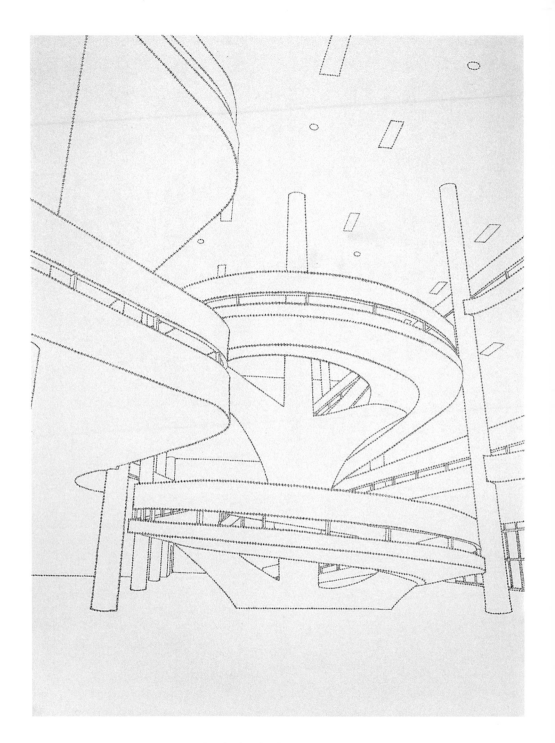

CAT 6: Paulo Climachauska, 'Projeto moderno/Bienal', permanent ink on wall, 2004 (2006)

6
Paulo Climachauska
(Brazilian, born 1962)

'Projeto moderno/Bienal', 2004 (2006)
Permanent ink on wall, c. 300 × 228
Courtesy the artist and Millan Antonio, São Paulo

Paulo Climachauska:
TO THINK of the construction of various systems (artistic, political, economic, etc...) in terms of subtraction and exclusion rather than by means of addition, accumulation and the deposit of experiences, values and ideologies.

 To understand the systems not as the product of adding the diverse parts to form a whole, but as a result of a process of excluding and subtracting everything that is not pertinent to its characterisation and preservation, proposing that the seizure of the world is only made possible by means of abandoning it.

7
Luisa Lambri
(Italian, born 1969)

'Untitled (Palácio da Industria, #03)', 2003
Framed laserchrome print, 105 × 92
The artist and Galerie Paul Andriesse, Amsterdam

Luisa Lambri:
MY WORK arises from the condition of being a female photographer in a male-created world. I try to inject a female point of view into my photographs of buildings designed mainly by men, and in that way I distance myself from the dominance of modernism in the architecture and aesthetic of twentieth-century Western culture.

(2004)

8
Detanico Lain
(Angela Detanico & Rafael Lain, Brazilian, born 1974 and 1973)

'Utopia', 2001
Digital typeface (exhibition logo), variable dimensions
The artists and Galeria Vermelho, São Paulo

Detanico Lain:
IN 1920S Vienna the philosopher and social scientist Otto Neurath *imagined* a visual system of communication that could pictographically represent individuals, objects and actions. The Isotype – International System of Typographic Picture Education – was intended to be more immediate, intuitive and universalising than written languages, although it was conceived of in their image. As a graphic reflection of the world, the pictograms of the Isotype microcosm recombine themselves to diagrammatically represent facts, narratives and statistics, simplifying a message to the essential features that correspond to a concrete experience of reality. Neurath believed that from this single and universal reality his system would eschew prior learning and transcend cultural barriers, becoming 'a basis for a common cultural life and common cultural relationship'.

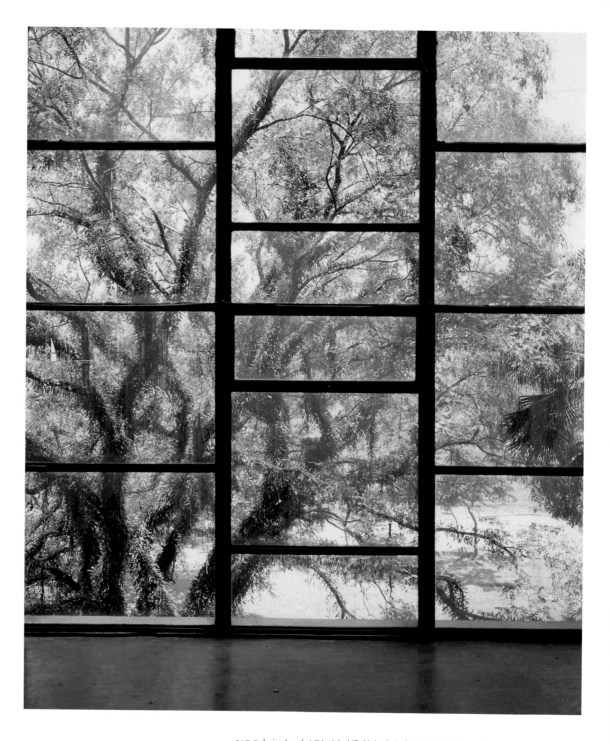

CAT 7: Luisa Lambri, 'Untitled (Palácio da Industria, #03)', Framed laserchrome print, 2003

uppercases

lowercases

CAT 8: Detanico Lain, 'Utopia', digital typeface (exhibition logo), 2001

Isotype's once inspirational modernism has been covered by dust in postmodern times. The concept of reality has shattered and the utopia a planned and controlled perfection has been diluted in the liquid modernity of our times. It is impossible to foresee everything. Neurath's pictograms proved themselves to be insufficiently intuitive and conditioned to cultural norms, and were not economical enough for his system to substitute verbal language in the way he had dreamed. However the Isotype project did not vanish: the visual representation of ideas and objects is widely utilised for situations such as signs in public places. Nowadays Isotype's descendents populate airports, restaurants and public buildings. The communication has *imagined itself* from Isotype's own inheritance.

In corroboration of the distance between *idealisation* and *realisation*, the meaning of the word utopia slips from the myth of an *ideal* state to the irony of an *unrealisable* reality. The projects of transformation are transformed at the same time as they transform; the mistake, the unforeseen, the improvised, constitute the work. Fact scorns categorisation: contradictions co-exist, organise themselves and complement each other. It is in this territory between disbelief and acceptance that we place 'Utopia', a typography created in 2001 as a portrait of modernist architecture in the landscape of large Brazilian cities today.

In 21st-century São Paulo, the clean lines of modernist projects co-exist with the tangle of electricity cables. Open spaces are fenced off. Surveillance cameras, guard booths, rubbish skips

and clutter spread through the streets filling the lacunae of urban and social planning. A city in constant transformation, a playground for skaters and a field for paper pickers, São Paulo is a set that rebuilds itself at a speed that defies expectations. Similarly, Rio de Janeiro, Belo Horizonte and Brasília are made up of complex landscapes where modernist rigour co-exists alongside the uncontrolled rise of spontaneous, chaotic and improvised urban elements.

We created 'Utopia' as a liquid portrait of this contamination. The urban elements, represented by pictograms, combine themselves like the letters in a text in order to graphically describe the real experiences of Brazilian cities. Projects by Oscar Niemeyer impose themselves as icons of modernism; fences, banners and gratings infiltrate like symbols of a population's responses to its own needs. Organised typographically, the latter are lower case and the former upper case letters. Not without irony. They organise themselves in a system of elements to be utilised, a portrait in power, a map that redesigns itself every time the typography is employed. Imagine purely modernist cities, utopias in upper case, or sketch urban entanglements in lower case. Or even write topographies where the foreseen and the unexpected, control and chance, project and clutter, can superimpose and transform themselves. These are our favourite versions.

www.detanicolain.com

9
Artur Barrio
(Brazilian, born in Portugal 1945)

'Situação… DEFL… +S+… ruas… Abril…'
[Unleashing confusion on the streets… situation], 1970
Slide show on DVD (projection), dimensions vary
Galeria Millan Antonio, São Paulo

Artur Barrio:
In my work, photos, films, etc. it is not the work, it is a *Registro*, … (Record) of the work.

(1970)

10
Grupo 3NÓS3
(Mário Ramiro, Hudinilson Jr.,
Rafael França, Brazilian all born 1957,
França died 1991)

Photographs and newspapers relating to temporary
interventions in São Paulo:
'Arco 10' [Arch 10], 1981, 'Ensacamento' [Bagging], 1979, 'X-Galeria', 1979,
'Interdição' [Interdiction], 1979
Courtesy Mário Ramiro and Hudinilson Jr.

Mário Ramiro: 3NÓS3 AND URBAN INTERVENTIONS IN SÃO PAULO
AT THE END of the 1970s and the beginning of the 1980s there arose in Brazil, and especially in the city of São Paulo, a new generation of artists working systematically with what became known here as 'urban interventions'. These actions, normally carried out by groups or collectives of young artists, were aimed at occupying the city's public spaces. In many of these interventions, architectural spaces such as avenues, flyovers, parks and tunnels, as well as urban furnishings such as monuments, billboards and traffic signs, were the 'supports' used for each respective work.

Seeking autonomy from the traditional circuit of the visual arts, represented by galleries and museums, the urban intervention groups created works that coincided circumstantially with the rise of graffiti in various Brazilian cities; a movement that also occurred in many European and North American cities. Also, in a way similar to what was happening in other great cultural centres around the world, these manifestations aimed to bring about an expansion of the artistic circuit beyond institutional spaces. This 'emergent' art, which also included a kind of music, film-making and poetry in search of new spaces for its expression, became known as 'independent art', a movement that sought an 'alternative to the cultural market and industry'.

The rise of the urban intervention groups and the proliferation of graffiti can, in this context, be symbolically considered as a way of recovering the public spaces in the crucial period of political transition that marked the end of the military dictatorship in the mid-1980s. Among these groups, 3NÓS3, consisting of Hudinilson Jr., Rafael França and me, was responsible for many large-scale urban interventions realised in São Paulo between 1979 and 1982. Many of our works were created with large quantities of industrial material, sponsored by a São Paulo company and installed at strategic points within the urban network. The intervention projects effected by 3NÓS3 were conceived as 'drawings on the city's blueprint' – a visual mark imposed on and in dialogue with the architecture, even if it only lasted a short while. These works, which

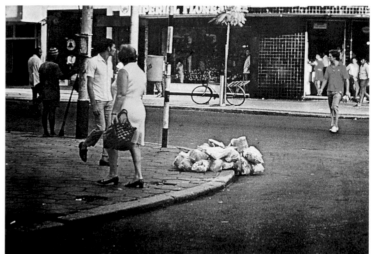
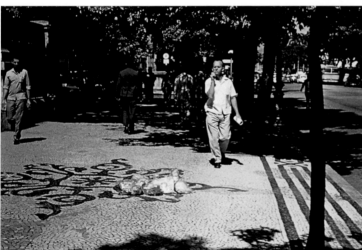
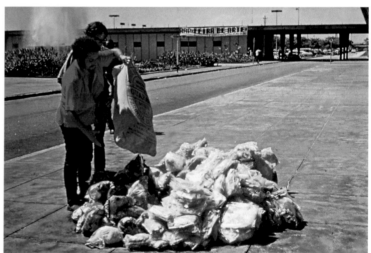

CAT 9: Artur Barrio, 'Situação… DEFL… +s+… ruas… Abril…' [Unleashing confusion on the streets… situation], slide show on DVD (projection), 1970

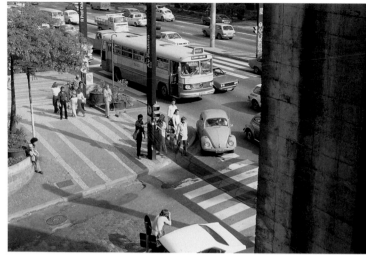
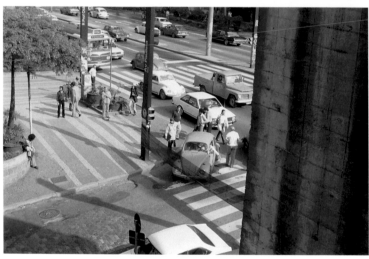
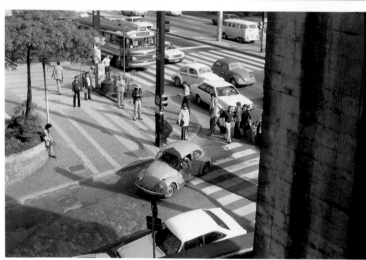

CAT 10: Grupo 3NÓS3, 'Interdição' [Interdiction], 1979

41

CAT 11: Ducha, 'Laranja' [Orange], Performance documented on dvd (projection), 2002

produced a visible alteration in the cityscape, were for the most part carried out clandestinely during the wee hours of the morning, when the city's space is slower and the streets, normally full of cars and pedestrians, were almost empty. Because of the temporary nature of our installations, we discovered that the best way to make them known to the public at large was through the printed and televised media, without which it would have been practically impossible to inscribe our work in that cultural moment. Although the physical existence of our works in the urban space was fleeting, their permanence as 'journalistic material' in the mass media was much longer. Much more than a material installation in a physical space, the urban interventions took on an existence as journalistic fact. For this reason we can go so far as to say that the interventions by 3NÓS3 can be seen as an embryonic form of media art that would be systematically developed in Brazil from 1982 onwards.

(2005)

11
Ducha
(Brazilian, born 1977)

'Laranja' [Orange], 2002
Performance documented on DVD (projection)
The artist

Ducha: LARANJAESCULTURATEMPO (INSIDE/OUTSIDE)
RIO DE JANEIRO, Friday, 1 pm. A man is carrying a paper bag with 100 oranges. At the intersection between Avenida Rio Branco and Rua Buenos Aires, with the traffic lights already flashing for pedestrians, the bag can withstand no more and it bursts…

'Laranja' was a fragment of time, not long enough to think about, but nevertheless it was an extended moment. Inversely, the video 'Laranja' takes nearly all its 7 minutes to show only the movement of the traffic and people. Without really trying, the video ended up being something

else, not merely a record of a happening (like *Jackass* on MTV), but took on its own life in a different way from my other works. A lot has changed since 1999, for me and for 'Laranja', but one thing still makes sense to me: experience is something you don't know the result of until you live it. 'Laranja' is a performance that doesn't aim exclusively for artistic status, more importantly it is an experience; the happening at the crossroads has not really finished, it was an ESTRUTURA -TEMPO [structure-time] printed on our minds and on the CCD camera. Who knows what it'll generate? Thanks to my brother Bernardo for suspending himself from that building while the oranges rolled…

12
Iran do Espírito Santo
(Brazilian, born 1963)

'Drops', 1997
10 photographs of concrete dice (*InSite 97* project), 29.3 × 22.7
The artist and Galeria Fortes Vilaça, Sao Paulo

Iran do Espírito Santo:
'DROPS', 2005, is a remake of an original work created in 1997 for *InSite 97*, a bi-national art event that takes place in Tijuana (Mexico) and San Diego (USA). For *InSite 97*, I created 20 dice in cast concrete, which I placed in several public locations: 10 in San Diego and 10 in Tijuana. No sign accompanied the object, which made the work anonymous and not necessarily identified as art. As I expected, many were stolen or vandalized, and this I considered part of the 'game'.

In 2005 I decided to remake the work in granite (see cat. 28), keeping its original form and measurements. This time no border issues are implied, the 'game board' is the actual art system (institution and market) which will place them according to its own rules – no different to the massive amount of art products circulating in the world everyday.

I consider the 20 granite dice as one piece. I have established that the units should be shown individually, so that its existence is conditioned by its own fragmentation.

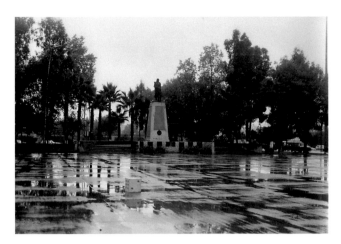

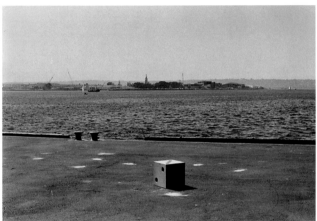

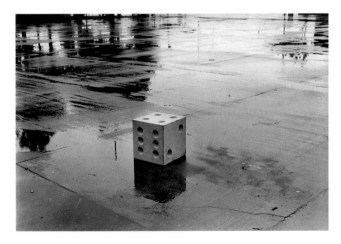

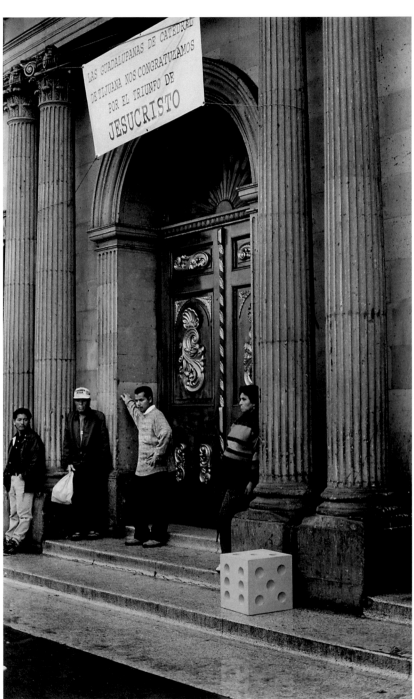

CAT 12: Iran do Espírito Santo, 'Drops', 10 photographs of concrete dice (*InSite 97* project), 1997

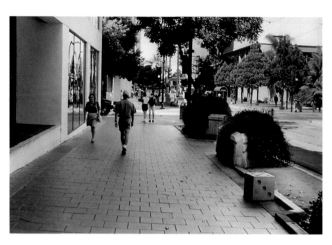
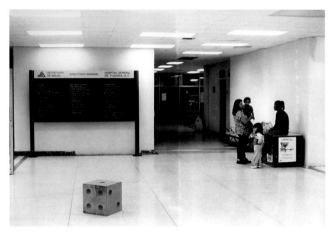
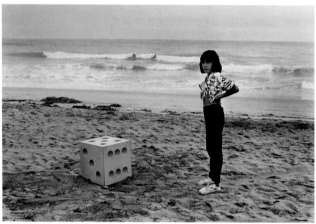
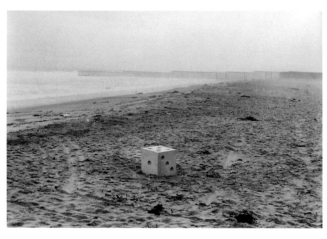
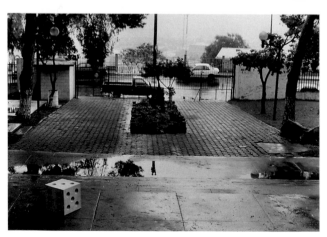

THE REX IS DEAD
LONG LIVE THE REX

NINGUEM DÁ PONTAPÉ
EM CACHORRO MORTO

REX TIME

ÓRGÃO OFICIAL DA REX GALLERY & SONS, FUNDADO EM 1966

Numero 1 3 de junho de 1966

AVISO: É A GUERRA

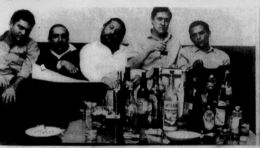

FALTA UM, MAS SEMPRE ESTA FALTANDO UM

[The main body of the newspaper is set in several columns of small type, largely illegible in this facsimile. Visible section headings include:]

Que Rex são êles

Depois da côroa, a panela

atendam sem falta a inauguração da já-memorável

REX GALLERY & Sons.

(Galeria Rex)

◉ ◉

especialistas em

Arte de Vanguarda

em São Paulo.

3 de junho de 1966 ● Rua Iguatemi 960

as 9 nove horas da noite

13
Grupo Rex

(Nelson Leirner born 1932, Wesley Duke Lee born 1931, Geraldo de Barros 1923–1998, Carlos Fajardo born 1941, Frederico Nasser born 1945 & José Resende born 1945, all Brazilian)

Ephemera relating to 'happenings' by Grupo Rex:
· *Rex Time no. 1*, 'Aviso: É a Guerra' [Warning: War is Declared], 3 June 1966 (facsimile)
· Photograph of the founder members of Grupo Rex (including Carlos Fajardo, Frederico Nasser, Nelson Leirner, Wesley Duke Lee, Geraldo de Barros), 30 September 1966 (facsimile)
· Conference invitation: Mario Schenberg, *Arte de Vanguarda* [Avant-garde Art], June 3 1966 (facsimile)
· Conference invitation: Flávio de Carvalho, *Dialética da Moda* [Fashionable Dialectic], September 30 1966
· Invitation to Wesley Duke Lee's *Happening*, João Sebastião Bar, 24 October 1963
· Invitation to Nelson Leirner's *Exposição não-exposição* [Non-exhibition exhibition], closing event at Gallery Rex & Sons on 25 May 1967
All Biblioteca Museu de Arte Moderna de São Paulo

· Rex Time no. 5, 25 May 1967
· Original Photographs of Nelson Leirner's Exposição não-exposição [Non-exhibition exhibition], 25 May 1967
Collection of Nelson Leirner (with thanks to Galeria Brito Cimino, São Paulo)

· Rex Gallery & Sons, bronze gallery sign, 1966
De Barros Family Collection

Nelson Leirner: GRUPO REX

MUCH HAS already been written about the Grupo Rex. However, apart from its documented history, what has remained with me for nearly 40 years, as founder and later as a group member, is my memory. I try to remember what hasn't been documented. The group's formation and the way in which we heralded its beginning seems to me to be relevant and little publicised.

In frequent unplanned meetings with Geraldo de Barros, Wesley Duke Lee and other artist friends, we talked about the gallery system, the critics who only championed conventional art, the absence of an editorial market, the lack of connection between our work and society and we also discussed how to find a way to help incorporate the much younger artists who suffered from the exclusion imposed on them by the art market.

It was then that I decided to get together a group of approximately 11 or 12 artists and invite them to a meeting at my house in order to discuss what I could have called (if a manifesto had been written on that night) 'Arte e Sociedade, seus desencontros' [Art and Society, their divergences].

Heated discussions and plenty of food and drink lent the meeting the mixed air of a political reunion and a party. At the end of the night only Geraldo, Wesley and myself had remained faithful to our objective, which was to declare war on the system. The others retired from the battlefield, afraid to stand up to the establishment and either lose the few privileges they had already earned or believe in a more promising economic future.

There was nothing else but for the three musketeers to announce, differently from Dadaism with all its manifestos, the three words 'WARNING: IT's WAR' which began the Grupo Rex.

14–16
Cildo Meireles
(Brazilian, born 1948)

'**Inserções em Circuitos Ideológicos: Projeto Coca-Cola**'
[Insertions into Ideological Circuits: Coca-Cola Project], 1970
3 Coca-Cola bottles with transfers, 18 (height of each bottle)

'**Inserções em Circuitos Ideológicos: Projeto Cédula** [Insertions into Ideological Circuits: Banknote Project]: (**Quem Matou Herzog?**) [Who Killed Herzog?] & (**Which is the place of the work of art?**)', 1970
Rubber-stamped bank notes, dimensions vary
All the artist

Cildo Meireles: INFORMATION

IN THE SUMMER of 1970 I was invited to take part in the *Information* exhibition at the Museum of Modern Art, New York. My invitation was through a letter from the curator, Kynaston McShine, who had seen my work in Rio de Janeiro during his visit to Brazil in 1969.

For *Information* I submitted the work 'Inserções em Circuitos Ideologicos' [Insertions into Ideological Circuits], 1970, which consisted of two projects:

1 The 'Coca-Cola Project', in which I transferred texts containing information and critical messages onto Coca-Cola bottles, placing them back into public circulation.

2 The 'Cédula Project', in which I transferred texts containing information and critical messages onto banknotes, placing them back into public circulation.

For the exhibition catalogue I produced the text 'Cruzeiro do Sul' [The Southern Cross]. The scenario for this text and the projects is this momentous period (the late 1960s and early 1970s) in the cultural synthesis of Western culture's history, which impelled a Brazilian artist in his early twenties to produce work that considered the following issues:

1 The painful political, social and economic reality of Brazil – a consequence to a large extent of:

2 The American system of politics and culture and its expansionist, interventionist, hegemonic, centralising ideology – without losing sight of:

3 The formal aspect of language; in other words, from an art-historical perspective, the need to produce an object that would lead to an productive, critical, in-depth consideration of projects such as Marcel Duchamp's readymades.

The 'Insertions into Ideological Circuits' offered explication of the first and second points and emphasized particularly the problems of language contained in the third.

The 'Insertions…' series presumed to follow the opposite path to that of Duchamp's readymades. The 'Insertions…' would act in the urban environment not as industrial objects set in

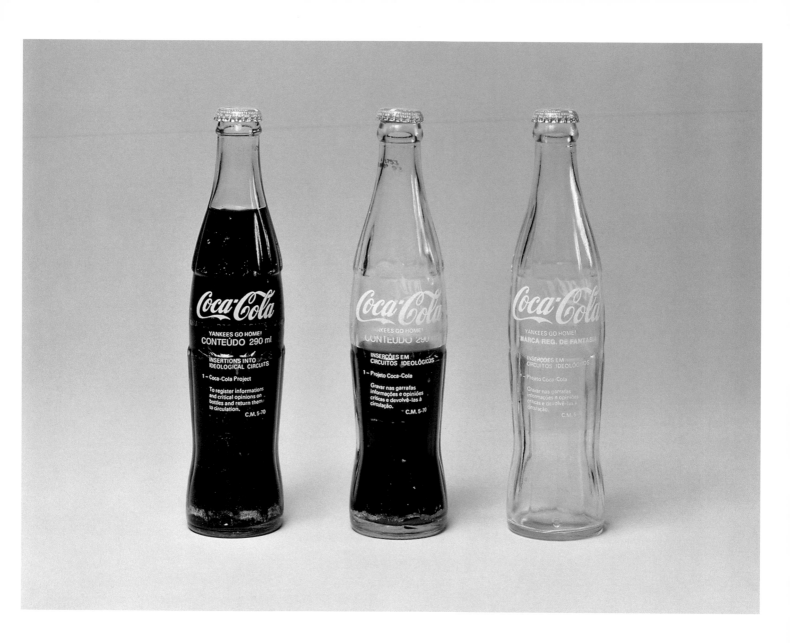

CAT 14: Cildo Meireles, 'Inserções em Circuitos Ideológicos: Projeto Coca-Cola' [Insertions into Ideological Circuits: Coca-Cola Project], 3 Coca-Cola bottles with transfers, 1970

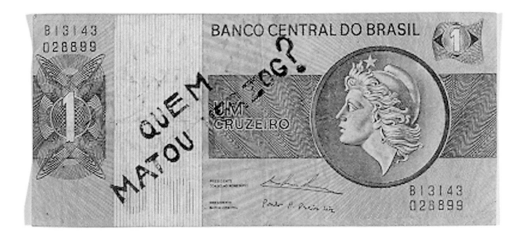

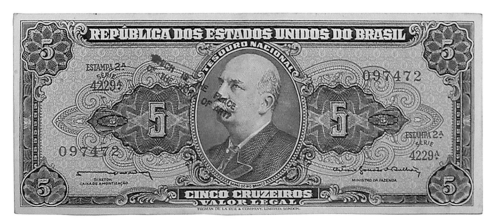

the place of the art object but as art objects acting as industrial objects. They were like graffiti, supported within a circulating medium.

They enabled an interaction between poetic language and discourse about a specific subject. Their effectiveness depended on the medium of art, and this effectiveness was not based on the quantity of occurrences of the work but on the declaration contained in the work itself, which was achieved by being stated, made explicit. What was thus an eminently social practice was perceptible as an 'artistic practice'.

These first 'Insertions…' explored the notion of a 'circuit'; they made visible, for example, the abstract systems of return and circulation in the processes of production, distribution and collection of containers for chilled drinks. This could be compared with the system that exists for the circulation of money in the form of coins and banknotes. The 'Coca-Cola Project' provided a metaphor which was artistically and politically necessary at the time. The 'Cédula Project' (with banknotes) had broader and more long-lasting implications.

50

Despite the healthy de-objectifying and decentralising practices of Conceptual Art, two of the central problems raised by the 'Insertions' in 1970 still persist today:

1 A failure to transcend the model of the 'pre-industrial' (not to mention pre-electronic) art object. A failure to arrive at objects which have an independent circulation: non-bourgeois objects.

2 A failure to transcend the 'art-system' model. Art systems (nowadays Brazilians commonly refer to the 'art circuit') have persisted practically without alteration; these systems are almost invariably based on impoverishing, fraudulent, decadent marketeering.

(1970/89)

17–20
Antonio Dias
(Brazilian, born 1944)

'Anywhere is my land', 1968
Acrylic on canvas, 130 × 195

'Cabeças' [Heads], 1968
10 painted wooden cubes, each 30 × 30 × 30
Both the artist

'To the Police', 1968
Bronze with metal tags, 3 pieces each 14 (diameter)

'Do It Yourself: Freedom Territory', 1968 (2002)
Titanium and vinyl text, 400 × 600
Both Daros-Latinamerica Collection, Zurich

Regina Teixeira de Barros: ANTONIO DIAS
ANTONIO DIAS was already recognised as one of the most important artists of his generation when he moved to Paris in 1966 on a study grant from the French government. After the events of May 1968 he was unable to renew his visa for leave to remain in France and so he relocated to Milan, where his production underwent a rapid and drastic transformation. Dias turned his back on Pop Art imagery – in which he had made explicit references to the increasing violence in Brazil following the military coup in 1964 and to North-American interventionist policies – and instead focussed on researching issues of a conceptual nature.

Words become a fundamental element, either through their inclusion in the works themselves or through their titles. In 'Cabeças' [Heads] and 'To the Police' for example, the titles lead, in a more ironic and subtle way than in his earlier work, to a political interpretation. In both, Dias alludes as much to the persecution by the military regime in Brazil as to the confrontations on the streets of the French capital in the spring of 1968.

In other pieces, like 'Anywhere is my land' and 'Do it Yourself: Freedom Territory', the articulation

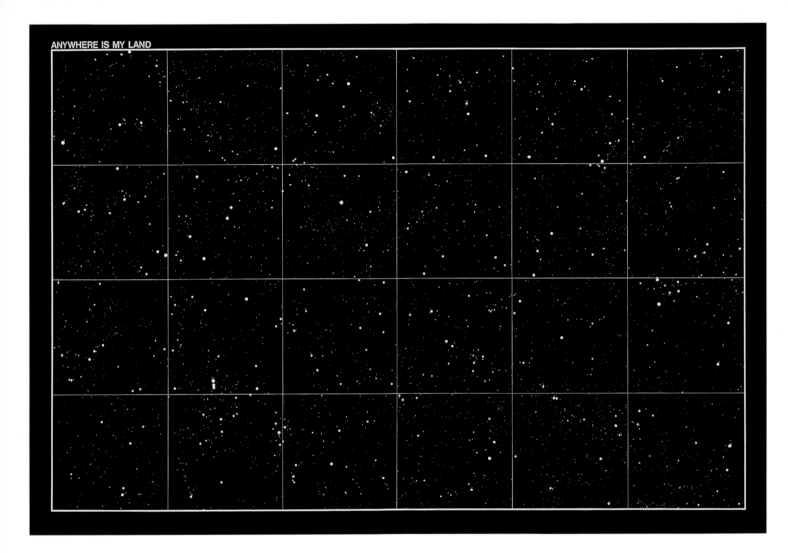

CAT 17: Antonio Dias, 'Anywhere is my land', Acrylic on canvas, 1968

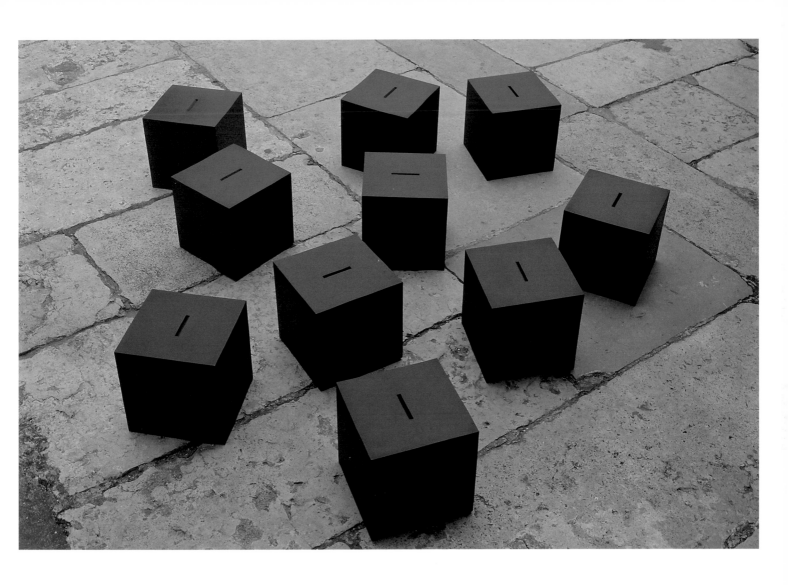

CAT 18: Antonio Dias, 'Cabeças' [Heads], 10 painted wooden cubes, 1968

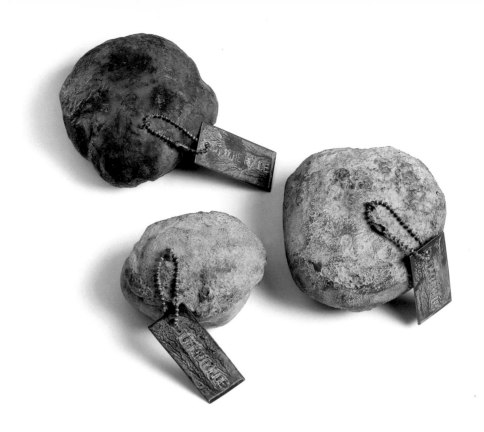

between text and image permits wide ranging interpretations that involve not only political aspects, but also personal experiences and debates about the essence and limits of art itself. By using a simple artistic vocabulary, Dias creates distinctions which demarcate the space and position of art. He inserts his production into an international context, one that is independent of local issues.

21–23
Antonio Manuel
(Brazilian, born Portugal 1947)

'Repressão outra vez – eis o saldo' [Repression once again – this is the consequence], 1968
5 covered silk screens, 122 × 80

'Corpobra' [Body/work], 1970
Wood, straw, photograph & rope, 200 × 49 × 47

'O corpo é a obra' [The body is the artwork], 1970
Photographs of unauthorised nude performance at Museu de Arte Moderna de Rio de Janeiro, dimensions vary
All the artist

54

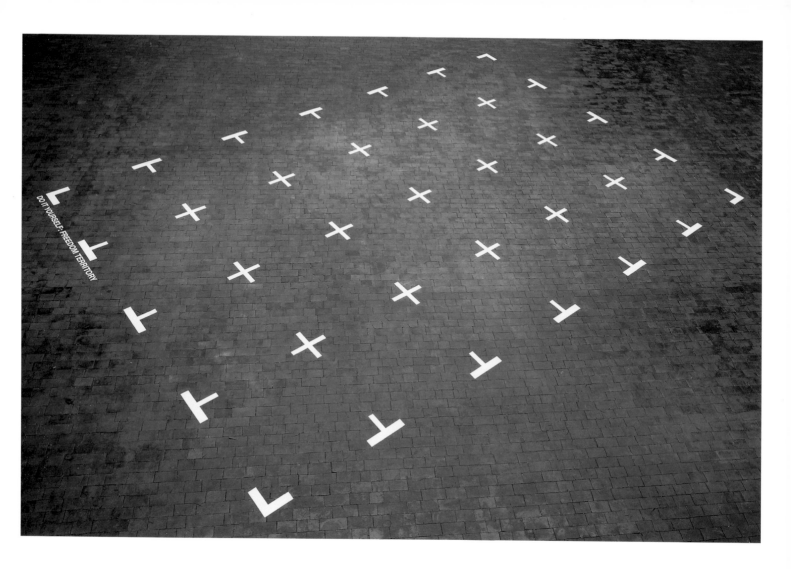

CAT 20: Antonio Dias, 'Do It Yourself: Freedom Territory', Titanium and text, 1968 (2002)

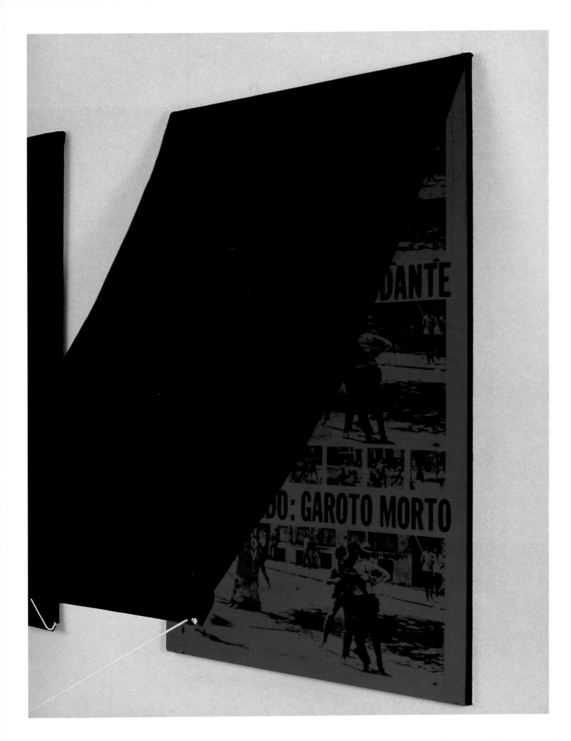

cat 21: Antonio Manuel, 'Repressão outra vez – eis o saldo' [Repression once again – this is the consequence], 5 covered silk screens, 1968

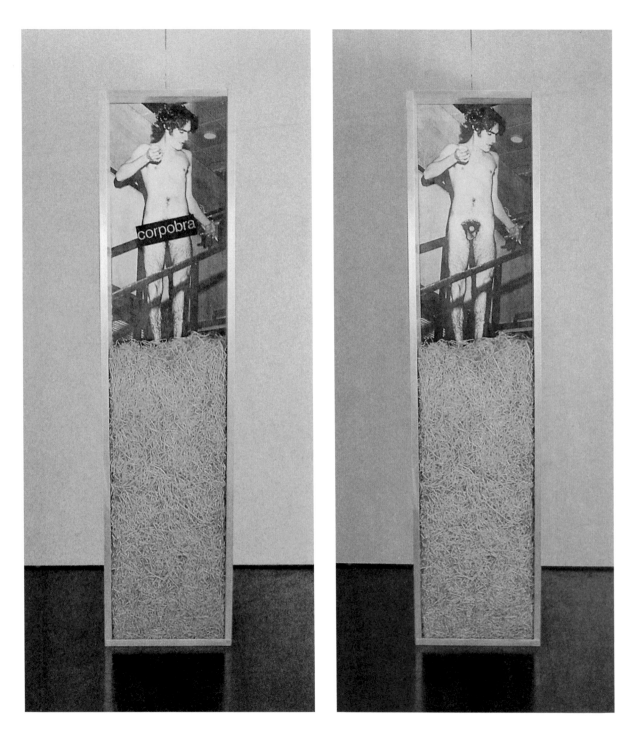

CAT 22: Antonio Manuel, 'Corpobra' [Body/work], wood, straw, photograph & rope, 1970

 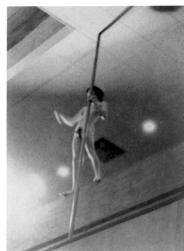 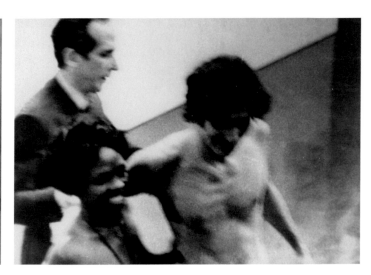

CAT 23: Antonio Manuel, 'O corpo é a obra' [The body is the artwork], photographs of unauthorised nude performance at Museu de Arte Moderna de Rio de Janeiro, 1970;

Antonio Manuel: IN THE ARTIST'S WORDS

I WANTED TO confront the art system and institutions, such as the museums and galleries, that exercised any type of artistic repression or censorship, and that discounted work they considered to be lacking in aesthetic qualities. The artists themselves also had a kind of self-censorship. The idea was to create a parallel language outside the distorted environment in the institutions which neither corresponded with our desires nor allowed space for our works. (However, at MAM – the Museum of Modern Art in Rio de Janeiro – there was a different spirit and that is why I started to visit it).[1]

The 'Corpo é a obra' and my act of nudity were a stand against these institutions. The main idea, when I entered myself as a work of art, was to question the criteria for the selection and judging of art works. I tried to stay throughout the judging of the work presented in the show; because I was the artwork I had the right to be in the judging area. But they didn't allow it, there was an argument and we reached a stalemate. In the end they asked me to leave and consequently refused to accept me as a work of art.

At the time, I thought that the strength of the actual aesthetic material couldn't correspond to the longing that we were experiencing. Neither painting nor sculpture had sufficient vehemence to represent that period of unrest. On the day the show opened, the work ended up in some way turning into something actual and consequential, consummating itself, independently of the judges and the museum.

(1999/2005)

1 Niomar Muniz Sodré was the founder of MAM in Rio de Janeiro, owner of the newspaper *Correio da Manhã* and the grand dame of Brazilian culture. She and Manuel became friends when, in 1969, the military closed down the MAM exhibition which included 'Repressão outra vez – eis o saldo'. Niomar hid the work to save it from destruction and also gave Manuel a hiding place so that he could avoid arrest.

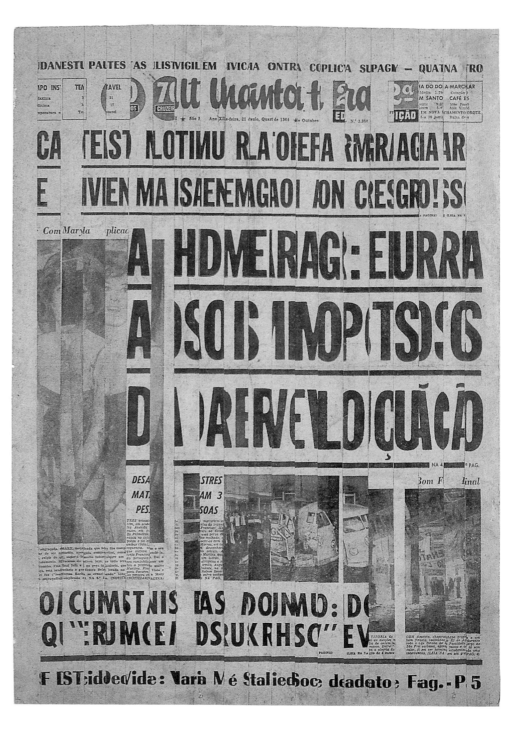

24
Waldemar Cordeiro

(Brazilian, born in Italy, 1925–73)

'Jornal' [Newspaper], 1964
Newspaper collage on paper, 65 × 22.5
Familia Cordeiro Collection

Waldemar Cordeiro: CONCRETE SEMANTIC ART

for centuries artists used space as a condition for semantic representations. the figures inserted in the axionometric perspectives of the middle ages or in the euclidean space of the renaissance became signs. both man and things take on meaning in space and in time (significant situation). pop art macro-naturalism is a deflowering of space.

in my work the object (ready-made) is constructed and also constructs a space, which ceases to be a physical space. the disintegration of the physical object's space is also semantic disintegration, the destruction of conventionalities and from another perspective, semantic construction: the construction of a new meaning.

(1964)

25–26
Jac Leirner
(Brazilian, born 1961)

CAT 25: Jac Leirner, 'Todos Os Cem' [All the One-Hundreds], rubber-stamped bank notes threaded on steel cable, 1987 (1998)

'Todos Os Cem' [All the One-Hundreds], 1987 (1998)
Rubber-stamped bank notes threaded on steel cable, 7.5 × 15 × 480
The artist

'Os Cem (Roda)' [The Hundreds (Wheel)], 1986
Bank notes and steel, 7 × 66
Fulvia Leirner Collection

Jac Leirner:

OH, THESE 100 *Cruzeiros* bills… They were printed a few months ago and they are already old and almost useless… What a strange presence… It comes as change, it is current money but it won't buy anything, not even a box of matches… And my pocket is always carrying so much of it, all this change… Well, I will start leaving it at a corner. I may well be realising the potential that this strange presence probably has; there are hidden values within its body for sure, it may well have the power to become art, to be used as a technique for sculpture, my desire… And more! If it becomes real art, it will be related to ideas that Cildo Meireles, Julio Plaza, Yves Klein, Andy Warhol, Arman and so many other artists and poets developed in the past, since the very beginning, the idea of value within art works… Oh, maybe it is finished! But not before I solve

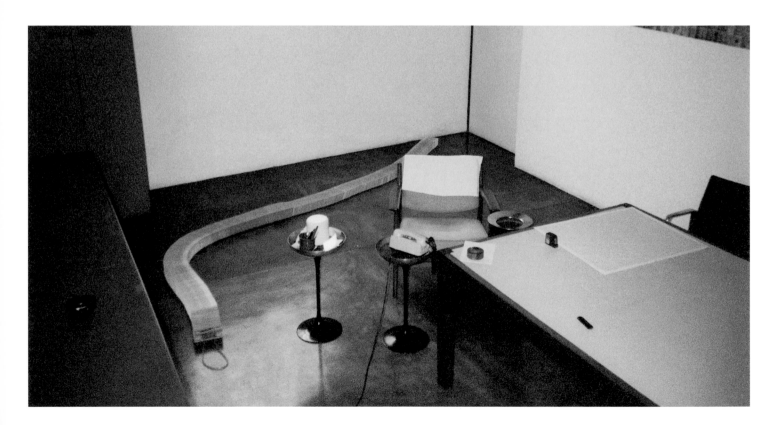

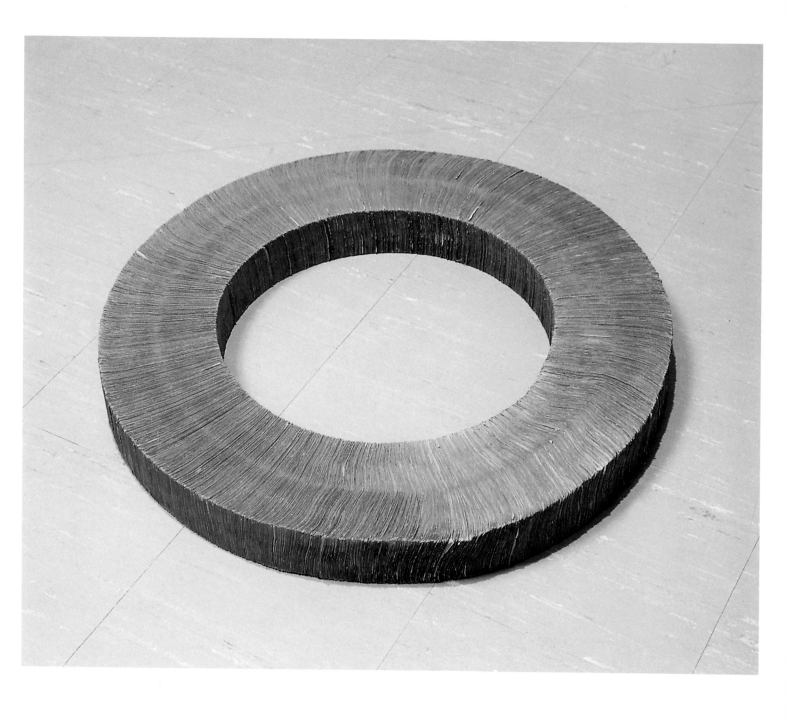

CAT 26: Jac Leirner, 'Os Cem (Roda)' [The Hundreds (Wheel)], bank notes and steel, 1986

several problems. And for sure they will take me a few years… I need much more material to fulfil the potential of this strange presence. I need to find a way to maintain the banknotes aligned together so that the edge of the paper becomes a tiny part of the strange surface of the sculpture. By now I have a thousand of them in a block. Together, close to each other, they look astonishing and strange at the same time. This is a block of something and this something is money! I'll punch holes in each banknote so that hard or flexible materials can be used as the structures that will keep them together… And if I call them 'The One Hundreds'? Or 'All the One Hundreds'? But… What a coincidence! *Cem* [One Hundred] sounds like *Sem* [without] which suits the reality of these banknotes! They lack the possibility of being valuable, they are destitute. This is a strange situation… What does value mean in this country if within a year these *Cruzeiros* bills will probably be out of circulation, if our money is always becoming less valuable than the equivalent weight of blank paper? Sure! That must be the reason why so many of the banknotes (almost 10%) have hand-made inscriptions, writings, drawings, graffiti. I will definitely put the graffitied ones apart, they are exquisite and unique! All these subjects drawn and written in such a rough but poetic way will be organised: signatures, numbers, devils, couples, pornographic or political stuff! How peculiar… Most of them were written by the illiterate… What a reality, this one of mine… Together, these graffitied banknotes seem to be an image of this country's soul… They are becoming poetic! Let me accumulate all of them… Let me steal them from the world… They are worthless, they have these inscriptions, they have this special colour, this old pink. They may become part of something really beautiful! Not counting the adventures that are to come, like punching holes on current banknotes (what a crime!), going to banks and visiting their huge underground safes, leaving these banks with suitcases full of money after exchanging them for a few valuable banknotes! Travelling with these suitcases, taking them everywhere in the world… Oh… I feel as if I am in a movie, *Cruzeiros, Cruzados, Cruzados Novos*, with or without stamps, here I go!

'**Zero Dollar**' & '**Zero Cruzeiro**', 1978–84
Offset lithograph on paper, dimensions vary
The artist

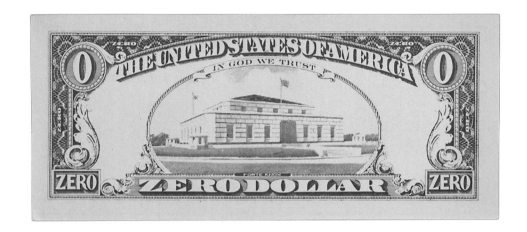

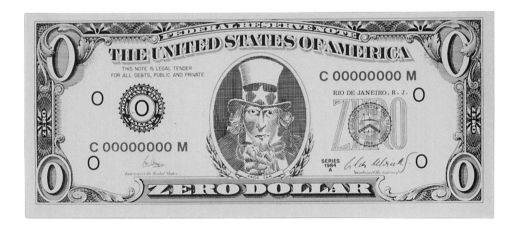

28
Iran do Espírito Santo

'**Drops**', 2005
Carved granite. 40 × 40 × 40
The artist and Galeria Fortes Vilaça, São Paulo

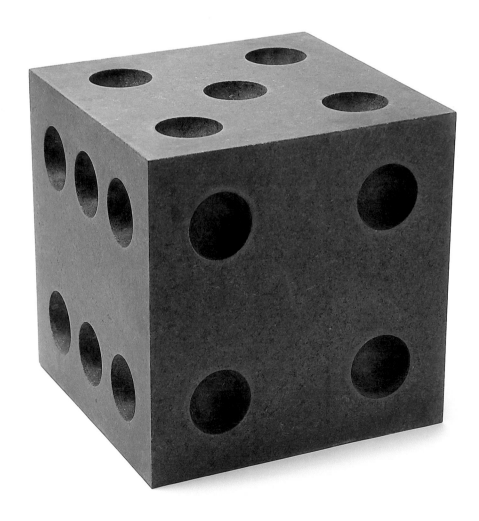

29
Jarbas Lopes

(Brazilian, born 1964)

Série 'O Debate' ['O Debate' Series], 2005
Plastic, 250 × 380 × 10
Galeria Millan Antonio, São Paulo

Jarbas Lopes:
I ALWAYS think in terms of the balance between labour and the absence of labour.

30
Eduardo Srur with
Fernando Huck

(both Brazilian, born 1974 and 1975)

'Attack', 2004
DVD projection, duration: 3' 34"
Galeria Vermelho, São Paulo

Eduardo Srur:
OVER A PERIOD of two years I appropriated the large, outdoor advertising images that invade our daily lives and intervened with ink bombs. In the beginning, the actions were accomplished during the day without being recorded. Later, the attempts became documented 'strategic attacks' and more than 30 interventions were made and have served as material for the video.

The dynamics of this three-minute video lie in the use of advertising language in a game of irony and eroticism which was made through my subversive actions.

'Attack' is not only a criticism against advertising speculations, but also an aesthetic interference, since the colours and images are previously chosen to create a kind of 'action painting' in urban spaces. 'Attack' is an answer to the media's bombardment.

31
Rubens Mano

'Visor', 2004 (2006)
Plastic mask in bottle,
12 (height of each bottle)
The artist and Casa Triângulo, São Paulo

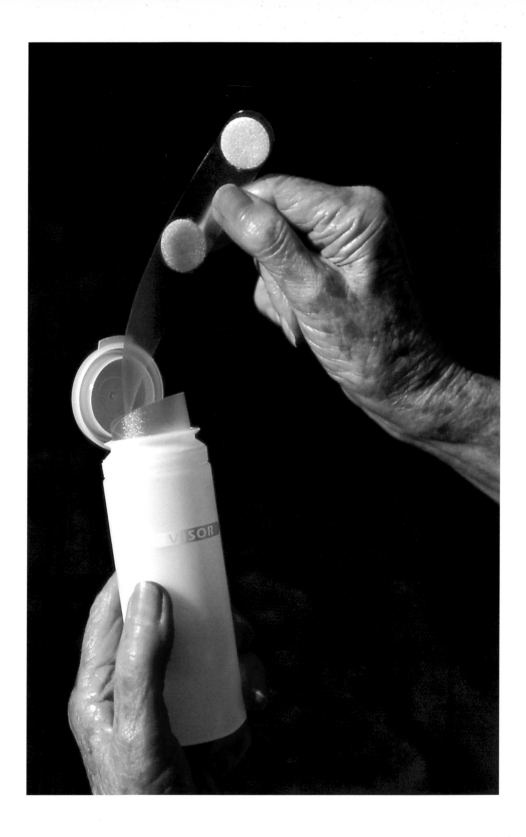

The Bienal de São Paulo: Between nationalism and internationalism [1]

1 I am grateful to Martin Grossman at USP, Anderson Tobita at the Museum of Contemporary Art (MAC) in São Paulo, and Anja Ziegler at inIVA in London for their generous assistance with my research.

2 The Bienal de São Paulo was initially called 'Bienal do Museu de Arte Moderna de São Paulo'. 'Ideology of Developmentalism' describes the wave of optimism that swept the nation during the 1950s. It is associated with an unprecedented industrial drive that sought in modernism, and particularly modern architecture, a representation for the modernisation of the nation.

3 M. Garlake, 'The British Council and the São Paulo Bienal', in: B. Rogers, (ed.), Britain and the São Paulo Bienal 1951–1991, São Paulo: the British Council, 1991, p. 13. On North American interests in the region see: note 10.

4 L. G. Machado, I Bienal de São Paulo (exhibition catalogue), São Paulo: Museu de Arte Moderna, 1951, p. 14. All translations are by the author unless otherwise stated.

5 Garlake, 'The British Council and the São Paulo Bienal', op. cit., p.16.

6 Aracy Amaral quotes an article by Ibiapaba Martins who already in 1948 discussed the existence of the idea for an art festival following the model of Venice with national and international awards. I. Martins, 'Duas entrevistas oportunas', Correio Paulistano, São Paulo, 1948. Quoted in: A. Amaral, Arte Para Que? A preocupação social na arte brasileira 1930–1970: subsídio para uma história social da arte no Brasil, São Paulo: Studio Nobel, 2003, (3rd. ed., 1st ed. 1984), pp. 237–238.

7 D. Pignatari, 'Desvio para o concreto', Folha de São Paulo, Caderno Especial 2, May 2001, p. 12.

8 Ibid.

THE BIENAL DE São Paulo emerged in 1951 (fig. 1) in the wake of the consolidation of the post-war geopolitical order, the hardening of Cold War politics, and on the eve of the Brazilian developmentalist project.[2] For European, and particularly North American government agencies the event offered fertile ground for economic infiltration by means of closer cultural ties.[3] For Brazilians it represented an unprecedented opportunity to survey international contemporary art. Lourival Gomes Machado, the event's Artistic Director, went even further in stating the Bienal's ambitions:

> In its own definition, the Bienal should fulfil two main tasks: to place modern art in Brazil, not only in simple confrontation, but in live contact with the art of the rest of the world, while São Paulo would attempt to conquer a central position within the artistic world.[4]

At a local level, the Bienal's historical significance has been compared to that of the *Modern Art Week* of 1922, which is widely recognised as having marked the introduction into Brazil of the modernist literature and aesthetics which was to be defined as *Modernismo*.[5] The fact that both events took place in São Paulo as opposed to Rio de Janeiro, the then federal capital, mirrors to a large extent the agency of their respective benefactors. If the *Modern Art Week* was the product of a nexus of initiatives by artists, writers and intellectuals, many of whom were beneficiaries of coffee production, the Bienal de São Paulo had as its central instigator the industrialist Francisco 'Ciccillo' Matarazzo Sobrinho. The former was organised to coincide with the centenary of national independence and offered an alternative to the 'official' celebrations held in Rio de Janeiro, the latter was initially considered for 1954 in order to integrate it with the celebrations of the 400th anniversary of São Paulo.[6] Products of the private sector, somewhat chauvinistic in character, each event consciously strove to be associated with national historical landmarks, while their respective benefactors were indicative of the socio-economic evolution of the city itself.

The price of coffee, São Paulo's principal product during the 1910s and 20s, collapsed after the Wall Street crash of 1929. The economic and political conditions of the 1930s therefore undermined the city's cultural and economic sectors until 1945. In the words of the poet and writer Décio Pignatari, the demise of President Vargas' regime in Brazil and the rise of Peron in Argentina had the effect of transferring the flux of 'selective' Italian immigration from Buenos Aires to São Paulo, 'transforming the state [of São Paulo] into an Argentina of Brazil, with a new coefficient, the Yankee' as opposed to the British capital and French culture traditionally relied upon by Argentina.[7]

> In 1951, the year in which the São Paulo Bienal was inaugurated, William Randolph Hearst, the inspiration behind Citizen Kane, died. Nevertheless his inheritor and avatar was already [in Brazil], and it was São Paulo that Assis Chateaubriand intuitively chose as the headquarters for his operations. The pro-fascist Matarazzo, the ex-fascist Bardi, the mysterious Franco Zampari and others, built in a few years the most impressive artistic structure in Latin America: the Museum of São Paulo (MASP) by Chateaubriand/Bardi; the Museum of Modern Art (MAM) by Ciccillo Matarazzo; the Brazilian Comedy Theatre (TBC) and the Vera Cruz Film Company by Franco Zampari.[8]

FIG 2: Victor Brecheret in his studio in the 1950s. A small version of 'The Indian and the Fallow Deer' is by his right elbow.

9 Matarazzo had been the commissioner for the 1948 Brazilian representation at the Venice Biennale, Garlake, 'The British Council and the São Paulo Bienal', op. cit., p. 13.

10 D. Peccinini, *Brecheret: a linguagem das formas*, São Paulo: Instituto Victor Brecheret, 2004, p. 289. Quotation from the English translation in the book. Another version of events emphasises the rivalry between Chateaubriand and Matarazzo. See: L. Amarante, *As Bienais de São Paulo*, São Paulo: BFB, 1989, p. 15 and p. 18.

11 See: G. M. Teles, *Vanguarda Européia e Modernismo Brasileiro*, Petrópolis: Vozes, 1997, (13th ed., 1st ed. 1972), pp. 308–10.

12 The site had been the focus of a dispute between Matarazzo and Chateaubriand and was awarded to the latter due to a technicality. See: Amarante, *As Bienais de São Paulo*, op. cit., pp. 14–15.

13 V. Artigas, 'A Bienal: expressão da decadência burguesa', *Hoje*, São Paulo, 12 August 1951. Quoted in: F. Alambert, *As Bienais de São Paulo: da era do Museu à era dos curadores (1951–2001)*, São Paulo: Boitempo, 2004, p. 46. 'Sharks' was a derisory term expressed by the left in defining corporate capitalists.

For Pignatari, underlying the sense of renewal that pervaded the 1950s was the fact that the international culture capital was no longer Paris but New York. This provided a new impetus governed by an Anglo-Saxon industrial mentality far more in tune with the metropolitan spirit of São Paulo than the Francophile capital Rio de Janeiro. This sentiment is confirmed by the enterprising spirit of Matarazzo, who, having founded the Museum of Modern Art in São Paulo in 1948, almost immediately began planning a means of placing the city within the international art circuit.[9] Central to the institution's ambition was the notion that abstract art represented the natural outcome of modern art. This notion of aesthetic progress was emphasised by the museum's inaugural exhibition *From Figuration to Abstraction* in 1949. Such beliefs were informed by the 'Good Neighbour' policy promoted by the United States, as industrialists such as Chateaubriand and Matarazzo found themselves under the 'guidance' of the North American model:

> The main reference for the *Paulista* corporate sponsors of modern art was the owner of the Standard Oil Company and president of the New York Museum of Modern Art (MoMA), Nelson Rockefeller. Thus, having the United States as an example, the decade of the 40s was marked by discussions between business people and critics about what an institution of modern art should be like.[10]

Such ideals clashed with the trajectory taken by modern art in Brazil and caused upheavals amongst sectors of the local artistic community. Despite some isolated experiments, Brazilian *Modernismo* had not significantly engaged with abstraction. Its principal model had been the post-cubist *rappel à l'ordre* period. The prevailing Parisian 'fashion' for the primitive, in conjunction with a modern classical figuration, allowed the Brazilians to develop 'exotic' themes through a specifically modern yet national iconography. By the 1940s the legacy of the *Modern Art Week* had been questioned by many of its own instigators, yet the Brazilianist themes were still held dear by many practitioners, Emiliano di Cavalcanti being perhaps the most vocal amongst them.[11] Particularly during the 1930s, this position became engrained in left-wing politics as a means of relating art to the 'ordinary people' and rejecting what they saw as the bourgeois notion of the autonomy of art.

These facts, in conjunction with North American intervention and the corporate sponsorship of the Bienal's awards, set the stage for conspiracy theories and allegations of cultural imperialism that plagued the Bienal's opening ceremony at the Trianon building on the Avenida Paulista.[12] The architect Vilanova Artigas published an article entitled 'The Bienal: an expression of Bourgeois decadence' in which he argued:

> [...] the Bienal will create a class of purchasers of abstract art, a fact already evident amongst the 'sharks' who have associated their names with the event's prizes. This purchasing class and the government will understand the importance of so-called modern art. They will create a market for the artists who, following such measures, will have their problems resolved as long as they paint following the purchasers' desires, that is, that they paint like the Bienal.[13]

The art critic and Trotskyite militant Mário Pedrosa answered Artigas by associating revolutionary politics with radical abstract aesthetics, evoking the work of Malevich and Rodchenko

14 M. Pedrosa, 'A Bienal de São Paulo e os comunistas', *Tribuna da Imprensa*, 1951. Quoted in: Amarante, *As Bienais de São Paulo*, op. cit., p.17.

15 See: Amaral, *Arte para Que?*, op. cit., p.230.

16 The 'admission jury' was composed of Francisco Matarazzo, Tomás Santa Rosa, Quirino Camofiorito, Clovis Graciano and Luiz Martins. The prize jury was composed of: Emille Langui (Belgium), Eric Newton (UK), Jan Van As (Holland), Jacques Lassaigne (France), Jorge Romero Brest (Argentina), Marco Valsecchi (Italy), René d'Harnoncourt (USA), Wolfang Plelffer (Germany), Sergio Millet and Tomás Santa Rosa Jr. (Brazil) with Gomes Machado as chair. See: *I Bienal de São Paulo*, op. cit., pp.46 & 201.

17 Many artists representing Brazil had been selected from the ranks of *Modernismo*, including, Di Cavalcanti, Candido Portinari, Lasar Segall, and Brecheret.

18 A list of participating artists in the jury's selection can be found in: *I Bienal de São Paulo*, op. cit., pp.172–200.

19 The system of prizes was abandoned in 1979. Garlake, 'The British Council and the São Paulo Bienal', op. cit., pp.25 & 28.

20 See: Alambert, *As Bienais de São Paulo*, op. cit., pp.37–38.

21 For an excellent survey of constructivism in Brazil see: A. Amaral, (ed.), *Projeto Construtivo Brasileiro na Arte (1950–1962)* (exhibition catalogue), Rio de Janeiro and São Paulo: Museu de Arte Moderna do Rio de Janeiro, MEC–FUNARTE & Secretaria da Cultura, Ciência e Tecnologia do Estado de São Paulo, Pinacotéca do Estado, 1977.

22 See note 29.

in order to discredit the 'Creole Stalinist scribes that parrot Kremlin bureaucrats'.[14] If Artigas' critique had been directed at the North American claim that there was an ideological connection between abstraction and liberal capitalism, at the root of such controversies was a debate that spread throughout Latin America during the twentieth century, namely nationalism versus internationalism.[15] Although generally recognised as the event that confirmed the new abstract tendencies in the country, the first Bienal de São Paulo unconsciously incorporated the inescapable ambivalence of Brazilian culture: a simultaneously inward and outward-looking nation that only occasionally reconciles its Western self with its other internal selves. It could be argued that in 1951 such a dichotomy was expressed in the allocation of awards and the selection of the Brazilian national representatives.

The organisation of the exhibition operated on two distinct levels. On the one hand, committees from each nation would select a number of artists to officially represent their country and these were 'in their majority' accepted by the admission jury; on the other hand, another jury would select works from open submission.[16] Being included in the national section did not exclude participation in the open competition, as was the case of the pioneering sculptor of *Modernismo* Victor Brecheret who was included in both.[17] Whilst the Brazilian national representation placed a strong emphasis on *Modernismo*, the selection of prizewinners was more diverse and showed a greater emphasis on abstraction.[18]

Prizes and awards at major international exhibitions are often problematic affairs. The ambivalent role played by the press in simultaneously condemning and legitimising a work of art is as old as modern art itself, yet the issues raised in such debates do not automatically become historically pertinent.

The awards ritual at the first Bienal de São Paulo attracted as much controversy as the event itself.[19] Danilo Di Prete, who allegedly had close ties with Matarazzo, was awarded the national prize for painting.[20] Awarded the international sculpture prize, Max Bill's 'Tripartite Unity' was and still is consensually recognised as highly significant. Unlike Di Prete, Brecheret's national sculpture prize for 'O Índio e a Suassuapara' [The Indian and the Fallow Deer] did not attract controversy (fig.2), and it has subsequently become overshadowed by Bill's award. Such fates are intrinsically connected with the historical reading of the first Bienal. As the event is generally considered to lie at the origins of the influential Brazilian Constructivist project, the conjunction of both sculpture prizes could be interpreted as marking a dividing line, half way through the twentieth century, between the past and the future of modern art in Brazil.[21]

There is no evidence of reconciliatory intent on the part of the jury. On the contrary, they emphasised the abyss that separated those who still held *Modernismo* as the locus of national culture from a hitherto timid young generation of artists and intellectuals interested in the rationalist possibilities for art in the post-war era. While the catalogue claims that the awards jury took into consideration what was most innovative in art, such a statement seems at times hard to sustain with regard to the Brazilian artists. In the painting section it gave awards to seminal works of *Modernismo* such as Tarsila do Amaral's 'EFCB' [Central do Brasil Train Station] from 1924, a key work of the *Pau-Brasil* period that adapted a post-cubist style by referring to Brazilian landscape. However, the national representation contained work such as Anita Malfatti's 'A Boba' [The Fool] which was originally exhibited in her controversial exhibition of 1917.[22]

23 It was therefore not included in the catalogue but received a special mention during the awards due again to the critic's intervention.

24 F. Gullar, 'Teoria do Não-Objeto', *Jornal do Brasil*, Suplemento Dominical, 19–20 December 1959. For a translation of Gullar's essay and a comparative analysis with Donald Judd's 'Specific Objects', see: M. Asbury, 'Neoconcretism and Minimalism: On Ferreira Gullar's Theory of the Non-Object', in: K. Mercer, (ed.), *Cosmopolitan Modernisms*, InIVA and MIT Press: London, Massachusetts, 2005, pp. 168–189.

In hindsight, the disjunction between both prizes for sculpture is further aggravated by the knowledge that Franz Weissmann's 'Cubo Vazado' [Emptied Cube] had been rejected and that Abraham Palatnik's 'Aparelho Cinecromático' [Kinechromatic Apparatus] (fig. 3) only entered the exhibition following Pedrosa's intervention.[23] These were artists that would become central figures of the Constructivist avant-garde in Brazil. Palatnik's contribution to the 1951 Bienal had initially been rejected on the grounds that it did not fit into categories such as sculpture or painting. Palatnik's independent approach nevertheless inadvertently foresaw a key concept that would emerge in Ferreira Gullar's *Theory of the Non-Object* of 1959, whereby categories such as sculpture and painting were increasingly hard to distinguish.[24] Such a theory followed the conclusions of the Neoconcrete Manifesto, to which Weissmann was one of the signatories. In fact, with the exception of minor prizes for Ivan Serpa and Geraldo de Barros, the jury did not foresee in any significant way the so-called 'constructive vocation' that Brazil would so enthusiastically embrace during the course of the 1950s. The reliance on established figures of *Modernismo* could be explained by the fact that a Sérgio Millet, a figure from the *Modern Art*

25 Pignatari also stated that: 'At the second Bienal [...] the [national] grand prize had already been promised to Di Cavalcanti. However, the Brazilian group had not counted with the ethical integrity of Herbert Read, the great figure of artistic and literary criticism in England [...].' D. Pignatari, 'Desvio para o concreto', op. cit. p. 12.

26 Brazil was 'discovered' by Pedro Alvares Cabral on 22 April 1500.

27 O. de Andrade, 'Manifesto Antropofagico', *Revista de Antropofagia*, n. 1, São Paulo, 1928. For an English translation see: D. Ades, *Art in Latin America: The Modern Era 1820–1980*, New Haven and London: Yale University Press, 1989, pp. 312–3. See also: J. Gledson, (ed.), Roberto Schwarz: *Misplaced Ideas*, London: Verso, 1992, p. 9 and M. Asbury, 'Tracing Hybrid Strategies in Brazilian Modern Art', in: J. Harris, (ed.), *Critical Perspectives on Contemporary Painting*, Critical Forum Series, Liverpool: Tate Gallery Liverpool and University of Liverpool Press, 2004, pp. 139–70.

28 See: Asbury, ibid., pp. 152–7.

29 In 1917 Lobato had viciously attacked a pioneering exhibition of *Modernismo* showing Fauve and Expressionist inspired paintings by Anita Malfatti. The article also alluded to Oswald de Andrade as an elegant albeit overweight poet hiding behind the label of modernity. M. Lobato, 'A Proposito da Exposição Malfatti', *O Estado de São Paulo* (night edition) 20 December 1917. The newspaper article is reprinted in its entirety in: M. da S. Brito, *História do Modernismo Brasileiro: Antecedentes da Semana de Arte Moderna*, Rio de Janeiro: Civilização Brasileira, 1978, pp. 52–6.

30 M. Lobato, 'Resenha do Mês', *Revista do Brasil*, n. 50, February 1920, p. 169. Quoted in: M. Brito, *História do Modernismo Brasileiro*, Ibid., p. 112–113.

31 M. del Picchia, 'Brecheret', *Correio Paulistano*, 26 February 1920. Quoted in: M. Brito, *História do Modernismo Brasileiro*, Ibid., p. 112.

32 Ibid., pp. 179–180.

33 The event was held at the Trianon, the site where the first Bienal de São Paulo would be held thirty years later.

Week, was a member of the jury and that, according to Pignatari, not much thought was given to the national awards:

> The awards jury was composed of a mixed body of foreigners and Brazilians. At the first Bienal their main concern was with the international prizes, hardly aware of the national representation: the Brazilians were left to divide their share of the cake according to their own taste.[25]

Brecheret was awarded his prize for a seemingly abstract sculpture that on closer inspection anchors itself in the figurative tradition via the incisions 'drawn' onto the object's surface. Its theme, a native Indian struggling to overcome his game, maintains a close association with the repertoire of *Modernismo*. Native and regional legends had been particularly important in the assertion of national culture during the early twentieth century. They entered the vocabulary of *Modernismo* as a form of replacement for the European notion of Arcadia: a mythical Pre-Cabralian origin for the Brazilian civilization.[26] Indianist themes had already been present in the romantic Beaux-Arts Brazilian tradition in the second half of the nineteenth century. The poet Oswald de Andrade radicalised such notions by shifting the representation of the native away from ideals of noble savagery towards the image of the fearsome cannibal. The latter, which developed into the concept of Anthropophagy, became an Oswaldian metaphor for the irreverent appropriation of European culture, since the act of digestion presupposed the substance's integration within the self.[27] Such an aggressive posture was nevertheless politely transcribed into Tarsila do Amaral's paintings of the late 1920s, which engaged directly with the Anthropophagite theme.[28] In the context of the conservative cultural milieu of São Paulo in the early twentieth century, titles were sufficient indicators of intent, and Brecheret's elegant work similarly pacified sections of the press initially hostile towards the modern aesthetic. Nowhere was this more evident than in reviews by Monteiro Lobato, himself a novelist with regionalist inclinations.[29] Despite Lobato's previous anti-modern position he held Brecheret in the highest regard arguing in 1920 that:

> Honest, physically solid, morally entrenched in the conviction that the modern artist cannot be a mere 'eclecticising' agent of old forms but should remove his creation from the classical authoritarianism, Brecheret presents himself as the most serious manifestation of sculptural genius that has emerged amongst us.[30]

Of relatively humble origins, Brecheret's isolation from socialite modernist circles came to an end when in 1920, Oswald de Andrade, Di Cavalcanti and the poet Menotti del Picchia came across his studio by accident. Describing this chance encounter as a 'discovery' it was not long before they were heralding the sculptor as the 'incontestable Brazilian Rodin'.[31] The following year, del Picchia was presented with a bronze mask by Brecheret at a banquet in celebration of the author's publication of *As Mascaras*, an event – according to Mário da Silva Brito – which also served as a pretext for announcing the existence of the modernist group.[32] Central to this group were the figures of Malfatti as the scandalous painter and Brecheret as the reconciliatory sculptor.[33]

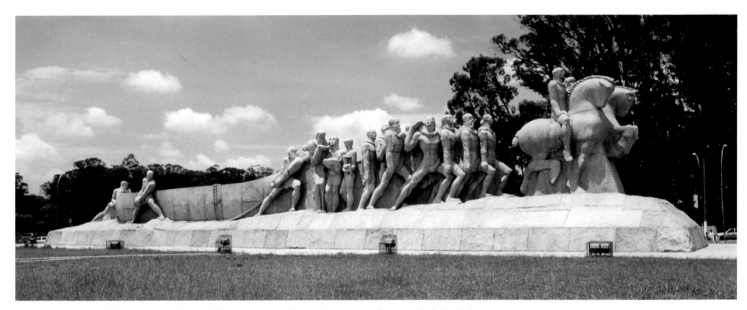

FIG 4: Victor Brecheret's 'Monumento as Bandeiras' [Monument to the Pioneers], 1920–53, in Ibirapuera Park, São Paulo.

Regard for Brecheret was consolidated when he was appointed sculptor for the 'Monument to the Pioneers' (fig. 4) in São Paulo (the commissioning body comprised of disparate supporters, namely, Lobato, del Picchia and de Andrade). The commission is significant as the monument was originally intended to mark the centenary of national independence in 1922, but as a consequence of political impasse, it was only finalised in 1953. Its site adjoined the Ibirapuera Park, which was designed by Roberto Burle Marx (landscape) and Oscar Niemeyer (architecture) for the city's 400th anniversary celebrations in 1954. Since 1953 the park has been the location for the São Paulo Bienal Foundation (figs. 5 & 6).[34]

Brecheret's gentle abstracting aesthetic and its association with both the Bienal and the legacy of *Modernismo* could only serve to emphasise further the distinct approach of the emerging São Paulo Concrete art group. Their 1952 *Ruptura* [Rupture] manifesto announced the desire for renewal, rejecting what it considered 'old' in favour of the 'new' premises to which it purportedly adhered.[35] The manifesto's rhetoric has become associated with the transformation of the nation itself through its emphasis on the creation of objects in the world, as opposed to abstracting forms from it. Politically this position was significant as it offered artists the chance to think of themselves as contributing new designs that could ultimately improve society at large. Rapidly shifting from a predominantly agrarian society to an industrial one, the new rationalist art, and the phenomenal rise of modern Brazilian architecture, only served to complement this new vision of national modernity. Central to this unifying vision are the developmentalist policy of industrialisation and the construction of Brasília, the utopian capital of the nation inaugurated in 1960.[36] The emergent Concrete and subsequent Neoconcrete avant-gardes are implicitly placed

34 Ibirapuera is itself a Tupi-Guarani name, meaning 'rotten wood' in reference to the then swamp-like region where today the park is situated.

35 The consensual notion that Concrete art in Brazil emerged amidst an atmosphere of rebellion against the tenets of *Modernismo* is seemingly coherent with the rhetoric of its manifesto signed by Lothar Charoux, Waldemar Cordeiro, Geraldo de Barros, Kazmer Fejer, Leopold Haar, Luis Sacilotto, Anatol Wladyslaw. The manifesto accompanied the *Ruptura* Exhibition at São Paulo's Museum of Modern Art in 1952, and is reprinted in: A. Amaral, (ed.), *Arte Construtiva no Brasil: Coleção Adolpho Leirner*, São Paulo: Compania Melhoramentos; DBA Artes Graphicas, 1998, p. 94.

36 Brasília was built in the central Brazilian wilderness. The competition was held in 1956, its revised master plan dates from 1957 and its inauguration took place in 1960.

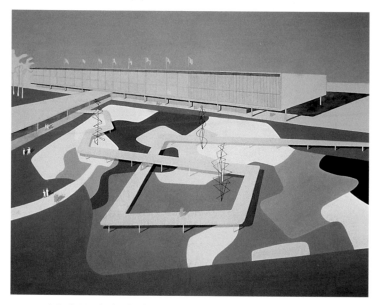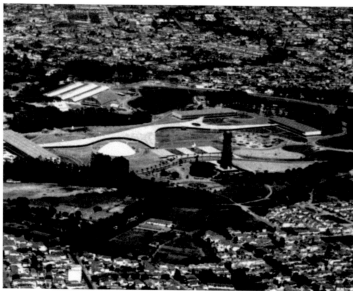

FIGS 5 & 6: Burle Marx's plan for Ibirapuera Park, São Paulo; Aerial view of Niemeyer's project in Ibirapuera Park c. 1954. The Bienal pavilion is the larger building to the left of the picture, which is linked by a covered walkway to his other buildings in the park.

37 M. Pedrosa, 'Reflexões em Torno da Nova Capital', *Brasil, Arquitetura Contemporânea*, no. 10, 1957. Reprinted in: A. Amaral, (ed.), *Mario Pedrosa: Dos Murais de Portinari aos Espaços de Brasilia*, Série Debates 170, São Paulo: Editora Perspectiva, 1981, p. 304.

38 M. Schenberg, *Pensando a Arte*, São Paulo: Nova Stella, 1988, p. 215.

39 See: A. Castro, Statement in: *O Globo*, 21 July 1983. Cited in: F. Morais, *Cronologia das Artes Plasticas no Rio de Janeiro: da Missão Francesa à Geração 90*, Rio de Janeiro: Top Books Editora Distribuidora, 1994, p. 223.

40 The international section of the II Bienal was held at the Palacio das Nações.

41 Kenneth Frampton discusses the issue quoting Max Bill's criticism of Niemeyer's Palace of Industry (the current headquarters of the Bienal foundation) in: K. Frampton, *Modern Architecture: A Critical Theory*, London: Thames & Hudson, 1992 (3rd ed., 1st ed. 1980), p. 257.

within such a context. Symptomatic of such an overarching association is the repeatedly quoted statement by Pedrosa in which Brazil is seen to be 'a country condemned to modernity'.[37]

At an international level, Concrete art was a diffused movement with wide-ranging influences. The appeal of its historical associations can be noted in remarks such as those of Mário Schenberg, who saw the pertinence of Concrete art in Brazil in its assimilation of an aesthetic language that passed through Malevich, Mondrian, and the Bauhaus and through to the developments proposed by Max Bill.[38] Concrete art in this sense could be seen to have 'corrected' the apparent 'incompleteness' of early Brazilian Modernism, in that it established a connection with the non-figurative tradition without subjecting itself to the North American model. As such it purportedly maintained its political integrity.

The radical character of the local Concrete art group was emphasised by Bill's role as prize-winning artist and general polemicist. In contrast to Brecheret's reconciliatory character, Bill's hard-line mathematical attitude appeared dogmatic even to certain 'abstract-geometric' artists.[39] However, in openly criticising Brazilian modern architecture when the second Bienal de São Paulo moved into its new Niemeyer-designed premises at the Ibirapuera Park, Bill inadvertently emphasised the link between modern Brazilian architecture and *Modernismo*.[40] In 1953, Bill spoke at a conference entitled *The Architect, Architecture and Society* held at the Faculty of Architecture and Urban Planning of the University of São Paulo (USP). Bill criticised Niemeyer's widespread inclusion of murals by Cândido Portinari (fig. 7), the principal pre-war painter of *Modernismo*, and additionally argued that certain structural elements in Niemeyer's buildings strayed away from functionalism.[41] Central to such attacks was the criticism of the Ministry of Education and

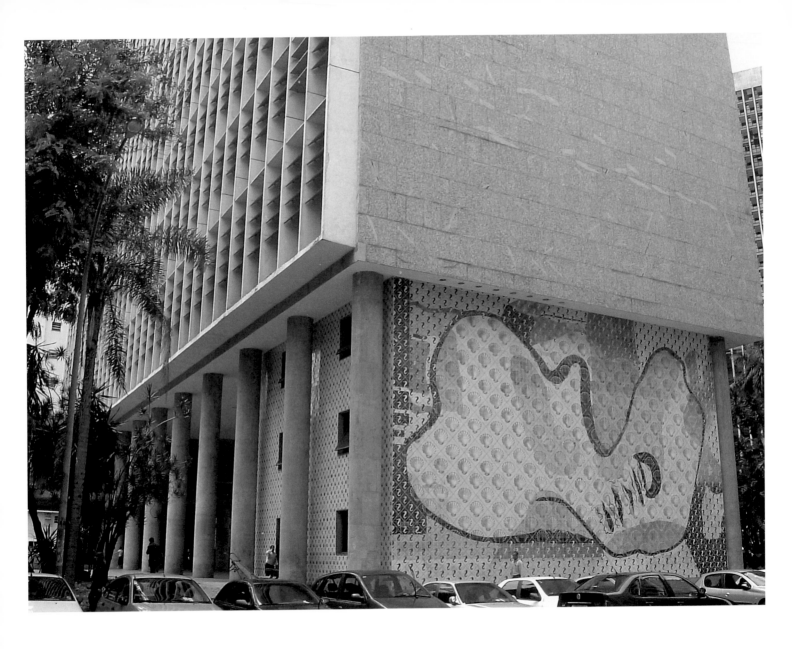

FIG 7: The Ministry of Education and Health in Rio de Janeiro showing Portinari's tiled mural on the façade.

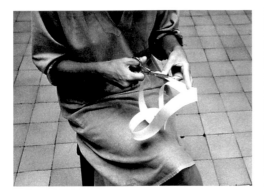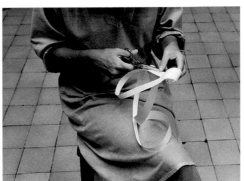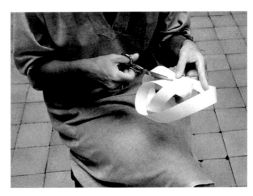

FIG 8: Lygia Clark's 'Caminhando' [Walking], 1963, from a photographic sequence of six prints.

83

The 1960s and 70s: The Difficult Decades [1]

Extract taken from 'Brazil 1950-1980: Time of Contrasts', first published in *Painting from Mercosur* (exhibition catalogue), Buenos Aires: Banco Montevideo, 2000 and specially revised in 2005

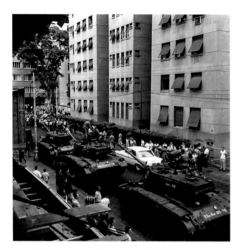

FIG 1: Tanks occupy the streets of Rio de Janeiro on 1 April 1964 (the day after the military coup).

1 W. Zanini, 'Duas décadas difíceis: 60 e 70', in *Bienal Brasil Século XX*, (exhibition catalogue), São Paulo: Fundação Bienal, 1994, p. 306.

2 H. de Campos quoted in S. Salzstein, *Mira Schendel: No Vazio Do Mundo* (exhibition catalogue), São Paulo: Marca D'Agua, 1996, p. 241.

THE SIXTIES were punctuated by the explosion of utopian visions and transformations all over the world. In Brazil the decade began with the climactic inauguration of Brasília in 1960; a new capital city which was the crossroads of political audacity and aesthetic concern. The confidence in democracy that had held sway since 1945 was dissipated by the resignation of president Jânio Quadros in 1961. This started a chain of events that led to the military coup of 1964 (fig. 1) and the despotisms of the military dictatorship which became worse after 1968. However, though this was a time of great difficulty and pain, it was also a period of significant creativity in music, theatre, cinema, literature and the visual arts.

At the beginning of the decade, the informal abstraction – *tachisme* – which had reached its peak in the V Bienal of 1959, was still clearly predominant, but its popularity had begun to decline at the same time as Neoconcretism began to make an impact. The Neoconcrete movement had been launched in 1959 when Ferreira Gullar (in tune with the phenomenological vision of Merleau-Ponty) set out his directives in a manifesto signed by Amílcar de Castro, Franz Weissmann, Lygia Clark, Lygia Pape, Aluísio Carvão and the poets Reynaldo Jardim and Theon Spanudis, and which was published during the *I Exposição de Arte Neoconcreta* at the Museum of Modern Art in Rio. They were joined by Hélio Oiticica, Décio Vieira, Osmar Dillon and later by Hércules Barsotti and Willys de Castro.

Shortly thereafter, Gullar conceived his inspirational *Teoria do Não-Objeto* [Theory of the Non-Object] in which he reflected on the revelation of form independent of exterior support, thus allowing it to drain from itself into itself. The impact of this separation (from Concretism) was stimulating, as were the new theories and the realisation that the consequence of abandoning Concretist rules was the freedom which is nowadays considered to be Neoconcretism's most important legacy. Other approaches which were already circulating (and being debated by Marcuse, McLuhan and Umberto Eco) began to multiply, such as experimentation with different languages, the break-up of categories, the insertion of new elements, the quest for audience participation and the integration of art with life.

Clark and Oiticica emerged from this period as major artists experimenting with the limits of three-dimensionality. To them, Haroldo de Campos added Mira Schendel (1919–1988), saying, 'I think that the three form a constellation…' [2] This third 'star' was never a part of the Neoconcretist movement and rather followed her own path. Lygia Pape, Amílcar de Castro and Franz Weissmann also experimented with sculptural ideas. As a group, the Neoconcretists developed their ideas over a relatively short time between 1959 and 1963 before separating. The artists nevertheless continued their production individually, and a few, such as Willys de Castro, Hércules Barsotti, Décio Vieira and Aluísio Carvão, stayed true to geometric abstraction, continuing to research its creation. Today, Neoconcretism is rightly recognised as a major international movement that originated in Brazil

In April 1963 the Museu de Arte Moderna de São Paulo was threatened with closure by its founder Francisco Matarazzo Sobrinho, and its art collection was transferred to the University of São Paulo. This had far-reaching repercussions, and in order to house the collection the University founded the Museu de Arte Contemporânea (MAC USP). The young professor Walter Zanini, who had recently returned to Brazil after a long period of study in Europe, was invited to be its first director. Within a short time Zanini managed to transform MAC USP into a lively and

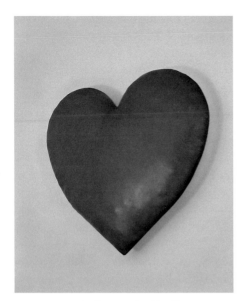

FIG 2: Antonio Dias, 'Heart to Crush', 1966

dynamic museum which was known for its critical revisions of modernism, for the dynamism of its international exchanges (highlights of which were the Grupo Phases exhibitions), and for its encouragement of the avant-garde (like the shows of Jovem Arte Contemporânea) which created opportunities for new artists and 'happenings'.

This effervescent start to the 1960s also saw the rise of Pop Art, which by the middle of the decade had been widely assimilated into the art market by both collectors and museums. With its main base in New York, Pop Art was readily acclimatised to the environment of different countries, appearing in new forms and with new designations, depending on the situation and conditions of each society. Many artists were in any case 'anthropophagic' and appropriated Pop Art without losing their own identity or autonomy, as in the case of numerous Brazilians who, in interviews at the time, denied belonging to the movement. It is also possible to see 'Otra Figuración' [Other Figuration], the Argentinian movement which influenced the Rio de Janeiro artists after Noé, Jorge de la Vega, Macció and Deira held exhibitions there in 1963, as coming close to this spirit, as did the various other European versions.

Pop Art (fig. 2) was characterised by the duality of an anarchic force of negation (the destroyer of existing forms) and a more constructive force which tended to build new artistic organisations. It had a determining role in the introduction of attitudes that expressed this clash, such as the use of pre-codified material, appropriations, the idea of public interaction and a clear critical perspective. This tension was present in the works and in the attitudes of artists from diverse artistic backgrounds (with which they managed to maintain links) such as the magic realist and herald of the new figuration, Wesley Duke Lee (b. 1931), Waldemar Cordeiro, who had recently turned his back on Concretism, Nelson Leirner (b. 1932) who came from an abstract background and Antonio Dias (b. 1944) who had formerly been linked with expressionist figuration.

After a fertile period of study in the United States and Europe, Wesley settled in São Paulo like '…a salmon in a silent current',[3] and a singular character who seemed permanently shocked by the contradictory nature of the art world. With his constant thirst for knowledge, Wesley threw himself into investigating the mysteries of sexuality, transcendence and utopia – the principal themes of his work – in a series of works which were initially notable for their Surrealist elements. He was motivated by the trouble he had in exhibiting the drawings called 'Ligas' [Connections/ Garters] (considered overtly erotic) to create the work 'O Grande Espetáculo das Artes' [The Great Art Spectacle], the first documented 'happening' in Brazil. In addition, as a reaction to the absurdities of the 1964 coup, he created a series of works which included the influential 'Campanha do Ouro para o Bem do Brasil' [Gold Campaign for the Good of Brazil]. Conceived away from frames and walls, the work penetrated the actual space of the viewer, transforming him or her from a passive onlooker into an active partner. He also fused more traditional methods with mass communication and new technology, and from 1966 he began to combine canvases with soundtracks to make objects that were like installations and precursory poetic machines. Wesley was an extraordinary teacher, and his work and attitudes (which excited radical reactions and followings) were disseminated by the Escola Brasil founded by four of his students in the 1970s.

Nelson Leirner was (and is) known for his sense of fun and spontaneity, but also for his considerable intellect. He debuted with his 'appropriations' and his work then developed through a series of satirical projects like the 'Altar de Roberto Carlos' (see cat. 13 on p. 88) or 'Homenagem

3 W, Zanini, 'Phases Em São Paulo' from *O Estado De São Paulo*, São Paulo: 25 July 1964, *Suplemento Literário*, p. 6.

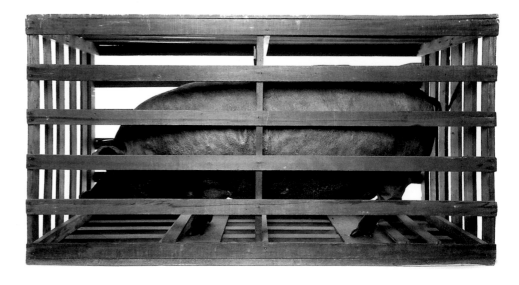

a Fontana' in which viewers could make their own Fontana-like 'cuts' in the canvas by opening or closing the zips in the work. He also expressed his dissatisfaction with the politics of the time through works like 'Bandeiras na Praça' [Flags in the Square]. In São Paulo, Leirner put up two hundred billboard posters entitled 'Aprenda Colorindo Gozar a Cor' [Colouring, Learn to Climax in Colour], in which the image of a woman in the throes of ecstasy advertised an orgasm as a product. These and other provocations reached their own climax when he sent 'O Porco' [The Pig] (fig. 3) to the 1967 Salão de Arte Contemporânea, which to his own consternation was accepted for exhibition (a decision he later ridiculed in his 'Happening da crítica'). He produced multiple objects, 'happenings' and installations in which he offered the public the opportunity to participate. His deliberate exceeding of the 'limits of art'[4] sometimes resulted in the violent destruction of his work. 'Anti-art' was therefore the phrase of the moment.

Antonio Dias had studied under Goeldi (1895–1961), and figuration appears in his early wall-based works with the snappy vision of expressionist comic strips (fig. 4). Because he was born in the arid northeast of Brazil, Mário Pedrosa called Dias' style 'pop sertanejo' [back country pop art] and indeed, the back lands were probably a vital influence on the sober and substantive forms of works defined by Dias' ethical positions on artistic and socio-political issues. His work evolved from the visceral assemblages, such as 'Nota Sobre a Morte Imprevista' [Note on an Unexpected Death], where he showed the impact of soft parts stuck to a dry, almost colourless painting (where the red is not pigment but blood). In 1968 his work moved on to images of mystery, marked by conceptuality and laced with tensions, like 'Anywhere is my land' (cat. 17) and 'The Hard Life'. He continued to experiment and openly researched the limits of objects and installations in works such as the ironic 'Poeta/Pornógrafo', as well as experimenting with methods ranging from video to hand-made paper, books, gold leaf and painting.

Waldemar Cordeiro, who had abandoned concrete art to create 'arte concreta semântica' [semantic concrete art], felt compelled to conceptualise the meaning of the new figuration. He

4 A. Farias, *Retrospectiva Nelson Leirner*, São Paulo: Paço das Artes, 1994, p. 137.

therefore made the 'Popcretos' [Popcretes] (fig. 5), a series of which featured fragments of everyday objects in his quest for a more appropriate form for the critical reflections and provocations which, according to Frederico de Morais, transformed each work into a manifesto.[5]

The Neoconcrete and new-figurative avant-garde were combined in many group exhibitions and events throughout the 1960s. One of these was *Opinião 65* (which was repeated in 1966). Organised at MAM–RJ by Jean Boghici and Ceres Franco, it reunited European artists and representatives from the new figuration, led in Rio by Antonio Dias, Rubens Gerchman, Carlos Vergara and Roberto Magalhães, joined by Hélio Oiticica (who had, by then, made his name with his 'Parangolês') and by Cordeiro. The exhibition had a definite political slant, although in the words of Frederico de Morais, in retrospect '…the further away *Opinião 65* is in time, the denser and clearer its (political) content seems to be. At the time however, this wasn't so clear'.[6] *Opinião* strengthened relations between the neo-figurative artists from Rio and São Paulo (mainly thanks to Cordeiro's commentaries), and consequently a few months later São Paulo hosted *Propostas 65* [Proposals '65], an exclusively Brazilian show which was followed by a cycle of debates.

Wesley Duke Lee, Nelson Leirner and Geraldo de Barros withdrew their works from *Propostas* in a protest against the military dictatorship which censored any works considered offensive to the regime. This act of solidarity united them and led to the creation in 1966 of Gallery Rex & Sons with José Resende, Luiz Paulo Baravelli, Carlos Fajardo and Frederico Nasser, all of whom had been Duke Lee's students (cat. 13). Gallery Rex was a cooperative, an experimental space, a space for reaction and a meeting place for younger talents such as Carmela Gross (b. 1946) and Marcello Nitsche (b. 1942). It acted as a cultural stimulator and showed that it was possible to integrate creative research with educational performance. Through consistent and explosive

L–R, FIG 4: Antonio Dias, 'The Hero's Remains', 1966; FIG 5: Waldemar Cordeiro, c. 1965.

5 F. de Morais, *Opinião 65*, Rio De Janeiro: Galeria De Arte Banerj, 1985.

6 Idem.

The founders of Gallery Rex & Sons including: Carlos Fajardo, Frederico Nasser, Nelson Leirner, Wesley Duke Lee and Geraldo de Barros, 1966. Leirner's 'Altar de Roberto Carlos' is in the background.

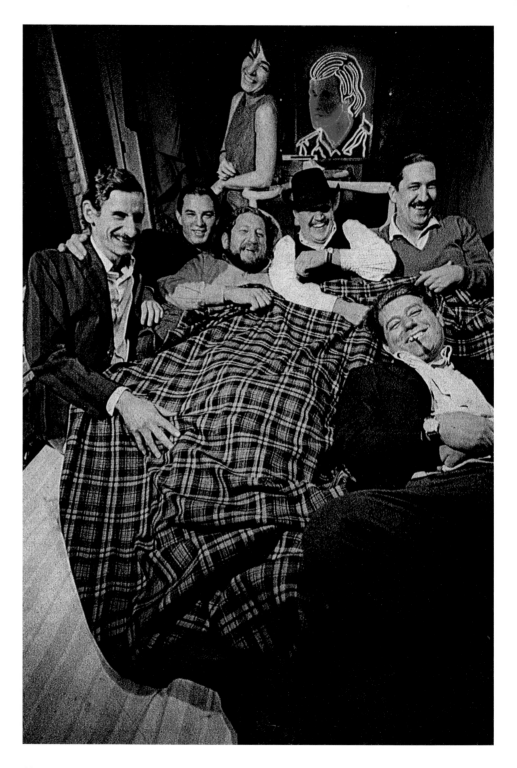

action it made an impact on the artistic environment with exhibitions like *Aviso: É a Guerra* and events like 'Taxi-painting' (fig. 6), in which the gallery offered canvas and paint to anyone who would pay to participate (their 'fare' for joining in was shown on a taxi meter). In spite of the origins of the gallery, artists like Wesley did not in fact accept the idea that art could be guided by ideological commitments, and the sensitivity of this subject was inevitably attended by problems. In the end however, it was the lack of financial and public support which put an end to the project, and a year and a half later, Gallery Rex closed with Nelson Leirner's *Exposição não-exposição*.

In Rio, Antonio Dias, Gerchman, Vergara and Roberto Magalhães did not go so far as to constitute an organised group, but they invariably worked together, attracting press attention and earning considerable respect. Their works focused on the underprivileged and the possibility of transformative action.

The exhibition *Nova Objetividade Brasileira* [New Brazilian Objectivity] emerged from the burgeoning diversity in Brazilian visual arts. It was organised by Frederico de Morais for MAM–RJ in 1967 and included Oiticica, Cordeiro and Mário Barata. The show presented a panorama of young art and was the vehicle for the *Declaração dos Princípios Básicos da Vanguarda* [Declaration of the Basic Principles of the Avant-Garde], a manifesto written by Oiticica in which he expressed a wish for art to communicate on a wider scale and for its integration into supposed reality. 'We Live off Adversity!' was its cry. This was also the start of the Tropicalist art/protest movement which spread to music and reached its peak in 1968 with events such as 'Arte no Aterro' [Art in the Landfill] and 'Apocalipopótese' [Apocolypothesis]. These were the last street-art manifestations to be tolerated in the comparatively relaxed phase of the dictatorship, which ended abruptly in December of the same year with the institutional decree no. 5.

In 1967 the United States took the exhibition *Ambiente USA: 1957–1967* to the IX Bienal. It was curated by William C. Seitz, and presented twenty-one artists who had links with Pop Art including Jasper Johns, Rauschenberg, Indiana, Lichtenstein, Oldenburg, Rosenquist, George Segal and Warhol, along with an Edward Hopper retrospective. Brazil was in a critically fallow period at that time, and while the Bienal judges could have chosen prominent artists like Lygia Clark, Oiticica, Mira, Wesley, Leirner and Dias among others, they chose not to make a strategic selection and instead accepted the work of 366 entrants. This created a babel-like installation which diluted and diminished the international impact of Brazilian art. There was insufficient energy in the Bienal Foundation to catalyse any new movements, make selections or mediate with the public. Some intellectuals had already left the country for political reasons; others were involved with militant groups. An international boycott began at the 1969 Bienal and only ended between 1981 and 1983.

The final years of the decade were not easy. There was a general exodus of artists and critics to other countries or professions, even though repression did not affect the visual arts to the same extent as in music and theatre. Nevertheless in the same period Brazil witnessed a boom in modernisation and economic development – the so-called 'economic miracle' which lasted until 1974 – which increased consumer spending power and, with the opening of new commercial galleries of contemporary art such as Ralph Camargo's ArtArt in 1970 and Galeria Luisa Strina in 1974, created the beginnings of an art market that was to stabilise in the 1990s. In addition,

those wealthy enough to collect contemporary art, of whom Gilberto Chateaubriand was a precursor, went on to multiply through the 80s and 90s.

As a consequence of the new economic prosperity there was an increase in the number of art books published and sponsored by private companies. The publishing of attractive books was allied with the sponsors' perception of the benefits of cultural marketing, along with the fact that art books operated in an area unaffected by censorship. As a result, this period was christened by Carlos Drummond de Andrade the 'Springtime of Books'.

In the early 1970s, the use of technology and participative events as seen in the art of the previous decade continued to resonate. Many of the artists who had already established their names – for example Antonio Henrique Amaral and João Câmara – now reached the height of their powers. In contrast, the absence of certain key personalities was notable. Lygia Clark, Oiticica, Antonio Dias, Roberto Magalhães, and Carlos Zílio, amongst others, chose to leave Brazil because of the military regime and only returned many years later.

Within the museological sphere, there were in the 1970s more and more major retrospectives of modernist artists, or survey exhibitions that focussed on specific aspects of Brazilian art history. *Quatro séculos de Arte no Brasil* [Four centuries of Art in Brazil], shown at MASP, revealed the support of the sponsoring companies who had begun to show interest in cultural promotion. The Bienal continued to be boycotted but, notably, the Pinacoteca do Estado in São Paulo was reopened and reinstated into the cultural life of the country through the energetic efforts of Aracy Amaral.[7] Walter Zanini's direction of MAC USP was also significant as he was receptive to conceptual art. This transformed the museum into a point of reference where international shows such as *Prospectiva 74* [Prospective '74], *Poéticas Visuais* [Visual Poetics] and *Vídeo Post* were held, along with numerous other national exhibitions and events.[8] MAC was the first of the museums to promote and publicise work created by artists researching the possibilities of projected images such as films, slides, holograms and video. Regular showings of what became known as Video Art were organised. Other state capitals, and in particular Belo Horizonte, saw strong artistic activity and the latter became a creative melting pot. In Rio, in this period, a huge fire at MAM–RJ tragically destroyed much of its collection.

The conceptual tendencies that developed at the end of the 60s and predominated throughout the 70s were antagonistic to Pop Art figuration. Conceptual art promoted singular works in which the artists' intentions became part of the work. The intention was to eliminate the art work together with traditional categories; to renovate methods by giving precedence to photography, offset and screen printing, photocopies, video and the written language. There was an emphasis on the body, the performance and on documentation (including the performance); books started to replace exhibitions, and works were sent through the post. This created an international communications network that was, in theory, capable of reaching anywhere in the world. Among its proposals was the elimination of the role of the critic, as this would pass the task of explaining the propositions that led to a work's creation to the artists themselves.[9] Correspondingly the critics would in turn become the artists' partners in artistic production.[10]

In Latin America, the rise of conceptual art coincided with the predominance of dictatorships and this gave it a different feeling from the self-referential sophistication that was being refined in the so-called 'alternative spaces' of other countries. In Brazil, conceptual art was nourished by

7 A. Amaral, *Arte E Meio Artístico: Entre A Feijoada E O X-Burguer*, São Paulo: Nobel, 1983, p. 326.

8 C. Freire, *Arte Conceitual e Conceitualismos: Anos 70 No Acervo do MAC/USP*, São Paulo: MAC/USP, 2000.

9 U. Meyer, *Conceptual Art*, New York: Dutton Paperback, 1972, p. 8.

10 M. Ragon in P. Restany, *Os Novos Realistas*, São Paulo: Perspectiva, 1979, pp. 11–21.

various elements, including the inheritance from Concrete poetry, the new concretist experience, the Pop Art spirit and the political circumstances. Conceptual art had already gone beyond the utopian postulates of the 1960s and, in contrast with the desire to merge art with life, conceptual artists tried to open art circles to new debates and critical positions regarding reality and artistic reality. Looking back from an already historical perspective in 1999, Cildo Meireles commented: 'In Brazilian conceptual art, so connected to sensuality, to the limits of the body and to pleasure, it is impossible not to think of seduction; but there are also political elements that are rare in art from other places in the world.'[11]

The undeniably significant 'visual poetics' were also identified with conceptual art and written language; *Verbivocovisual*, the title created by Haroldo de Campos for an exhibition, came to designate the genre that dealt with the relationship between the verbal and the visual. It was a tendency in which he, Augusto de Campos and Décio Pignatari never stopped working, as they persevered in the development of Concrete poetry (unlike Ferreira Gullar and Reynaldo Jardim who renounced their Neoconcrete works). They were joined by young poets and artists, and its paradigm was represented by the artists' books of Júlio Plaza and Augusto de Campos. Later, Júlio Plaza dedicated himself to creating electronic poetry images through videotext and holograms, and also developed a profound theoretic argumentation on the theme. Other artists like Ana Maria Maiolino, Mira Schendel and Lygia Clark also dedicated themselves to creating artists' books. Regina Silveira created installations and videos, and as a teacher played an important role in the formation and development of young talent.

The flow of these movements and attitudes went on without interruption, but by the end of the 70s another movement was taking shape. By 1984 a new generation of artists had clearly arrived, critics of conceptual hermetism and dispossession. It was hailed in the show *Como vai você, geração 80?* [How are you doing, 80s generation?], and signalled the introduction of the international trans-avant-garde into Brazil.

CACILDA TEIXEIRA DA COSTA
Translated by Juliet Attwater

11 P. Herkenhoff, G. Mosquera & D. Cameron, *Cildo Meireles*, São Paulo: Cosac & Naify, 2000, pp. 11–21.

Space and Democracy: Places for art in Brazil since the 80s [1]

FIG 1: Piscina do Parque Lage during *Como vai você, geração 80?* [How are you doing, 80s generation?], Rio de Janeiro, 1984.

1 With thanks to staff at the Museum of Modern Art of São Paulo.

2 M. Costa et al., 'Enraged Beauty', in F. Chaimovich (org.), *2080*, São Paulo; Museu de Arte Moderna de São Paulo, 2003, p. 171.

3 See E. Cockroft, 'Abstract Expressionism: Weapon of the Cold War', in F. Frascina and J. Harris (eds.), *Art in Modern Culture*, London: Phaidon, 1992, pp. 82–90, and Grasskamp, 'For example, Documenta, or, how is art history produced?', in R. Greenberg et al. (eds.), *Thinking about Exhibitions*, London: Routledge, 1996, pp. 67–78.

4 See F. Cocchiarale and A. Geiger, *Abstracionismo Geométrico e Informal – A vanguarda brasileira nos anos cinquenta*, Rio de Janeiro; FUNARTE, 2004.

5 See D. Peccinini, *Figurações – Brasil Anos 60*, São Paulo: Edusp, 1999, pp. 130–153.

DEMOCRACY RETURNED to Brazil at the same time as globalisation was winning the Cold War. The dictatorship which governed the country between 1964 and 1985 had not only affected the avant-garde but had also prevented criticism of more conservative art. During the mid-1980s experimental art moved into public spaces and this encouraged the growth of the contemporary art market in Rio de Janeiro and São Paulo. Since then, and for the first time, the national art circuit has expanded beyond a single centre.

In 1984, the Visual Art School of Parque Lage, in Rio, posed the question: *How are you doing, 80s generation?* Artists from all over the country, though mainly from Rio and São Paulo, agreed to participate in the exhibition, despite being obliged to pay their own fee and transportation costs. It was situated in the courtyard of the early 20th-century villa that housed the art school, based on the Mantovan Palazzo Te. This quadrilateral building, with an open pool in its centre, was located in the heart of a tropical forest, under the Corcovado Mountain.

> 123 artists from all parts of Brazil [stated the organisers] will place their work on and in the walls, doors, windows, pools, bathrooms, built spaces and vacant areas of the majestic Escola de Artes Visuais building, as well as the pathways, trees, grottoes and hidden recesses of Lage Park where it is located, in Rio de Janeiro.[2]

How are you doing, 80s generation? produced a national awareness of the survival of an art project that had been silent for fifteen years. Since the fifties, Brazilian art had suffered from the impact of North American international abstraction, promoted as the main aesthetic contribution of early modernism to the post-war period.[3] The creation of the Museum of Modern Art of Rio de Janeiro (1947), of the Museum of Modern Art of São Paulo (1948), and of the Bienal of São Paulo (1951) had the support of Nelson Rockefeller and of the Museum of Modern Art, New York. As a consequence, and from 1948, abstraction came to be seen as a foreign imposition, having first appeared in Brazil only during the Cold War. By the early 60s, young artists were looking for specific strategies of interaction with the Brazilian public, as a counterpoint to the abstract trend.[4]

After the military coup of 1964, the need for political opposition to the dictatorship hardened the critics not only to abstraction, but also to painting or sculpture generally as techniques which implied a passive beholder. In 1967, the Museum of Modern Art in Rio organised a group show with a catalogue written by Hélio Oiticica, who stated that there was a need for political commitment, the collective creation of art works and the participation of the public in interactive pieces, according to the supposedly playful nature of Brazilian culture.[5] However, the hardest moment of the dictatorship was yet to come; in December 1969, all groups were forbidden, dissolving the so-called 'Nova Objetividade Brasileira' [New Brazilian Objectivity]. The movement survived the 1970s only by means of individual production. In 1984, as democracy regained the streets in the 'Diretas Já' campaign for direct elections for a President of State, the aspiration of articulating a national network of contemporary art was once again possible.

The lack of curatorial criteria in *How are you doing, 80s generation?* marks the initial optimism of that decade. Total inclusion seemed possible, if only we could invent our future history with a brand new beginning. Brazil, in contrast to Chile and Argentina, was eager to forget its immediate

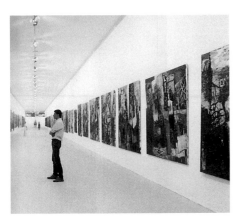

past and wanted to return to a point some twenty years earlier. In 1984, the pool in the Parque Lage was filled with water and paper airplanes, just as in 1969 it had been filled with *feijoada*,[6] for the anthropophagical film *Macunaima* by J. P. de Andrade, one of the last critical interventions before the torture began (fig. 1).

Private galleries and public institutions soon shaped a highly heterogeneous Brazilian production in line with an international agenda. In 1985, curator Sheila Leirner built parallel corridors for a section of the 18th Bienal de São Paulo called 'Great Canvas'. Large paintings by Brazilian and foreign artists were closely hung to form continuous galleries, in what was interpreted at the time as a 'neo-expressionistic' move (fig. 2). The reaction of artists and critics proved how conditions of meaning and value had changed. If contemporary Brazilian art was to criticise Brazilian culture after years of censorship, it had also to be acquainted with the international debate of the time, in terms of the last moments of the Cold War, the acceleration of a newly globalised world and the relative position of each country. Galleries such as Thomas Cohn and Anna Maria Niemeyer in Rio, and Luisa Strina, Subdistrito, Raquel Arnaud and Casa Triângulo in São Paulo, formed a local market for experimental artists, while exposing them to global competition at international prices.

As the 1990s began, it was clear that building democracy was about confronting our own history. Political corruption led to the 1992 impeachment of Collor de Mello, the first President of Brazil to have been elected after the dictatorship. Aids, economic inflation and the rise of urban violence in capital cities all led to greater narcissism, which might also be seen as the need for reflection. Curator Aracy Amaral explored this need in 1994 with the group show *Mirrors and Shadows*, at the Museum of Modern Art in São Paulo (fig. 3). Amaral's identification of international themes, such as the body and individual identity, emphasised the need for a curatorial discourse that would mediate contemporary issues in public institutions.

The rise of curatorial power led to a growing interaction between Brazilian artists and the kaleidoscopic succession of thematic biennials all around the world. As São Paulo's was still the only important Latin-American biennial, it was well placed to suggest new patterns for classifying art today. Nevertheless, the curatorial themes of the *Bienals* of the late 1990s were rather nostalgic. In 1996, curated by Nelson Aguilar, the theme was the dematerialisation of the art object (a North-American concept from 1972),[7] and in 1998, curated by Paulo Herkenhoff, it was 'anthropophagy' (a Brazilian concept dating back to 1928).[8] These *Bienals* were caught up in a major change in the practice of cultural events and in the definition of Brazilian culture itself. Their retrospective look should be understood in relation to the end of State cultural policy, a phenomenon of the early thirties. Both *Bienals* involved the new financial management of culture: a legislative framework which facilitated tax reduction by changing public debts into private sponsorship. A novelty of the 1990s, these laws implied that there was free competition for the ownership of an event, and that only once its status was acknowledged might it be seen to deserve State support. Now producers had to compete for sponsors by first presenting their curatorial projects, thus placing an emphasis on curatorial speech.

This situation started to benefit small groups willing to take risks for their own projects. In 1994, the group Arte Construtora, with artists Elaine Tedesco, Elcio Rossini, Fernando Linberger, Jimmy Leroy, Lucia Koch, Luisa Meyer, Nina Moraes and Rochelle Costi, organised site-specific

6 A traditional *cassoulet* of beans and meat.

7 See L. Lippard, *Six Years: The dematerialisation of the art object from 1966–1972*, Berkley and Los Angeles: University of California Press, 1997.

8 See J. Schwartz, *Vanguardas Latino-Americanas*, São Paulo: Iluminuras – Edusp, 1995, pp. 140–147.

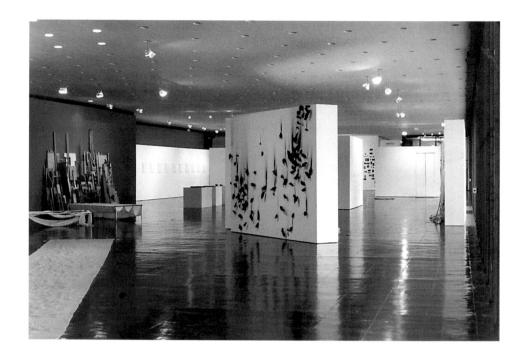

shows at the first modernist house in São Paulo, and in a 19th-century, Neoclassical residence in Rio. With this experience behind them, in 1996 they curated the occupation of an island in Porto Alegre by themselves and other artists, where people could go for free by boats paid for by private sponsors and the city fund for culture. During these three projects, the group would discuss what works they would create and as they started to clean up the sites, the garbage they found served as the basis for their work (fig. 4).

Eventually both phenomena, the rise of group art and the mixture of public money and private interests, coalesced into a debate about the spaces for contemporary art in Brazil. The 'white cube' modernist model was questioned in the group show *Ao Cubo* in 1997 by curators Luciana Brito, today a partner in the Brito Cimino gallery, and Martin Grossman, today in charge of the Permanent Forum of the University of São Paulo. They invited artists Ana Maria Tavares, Carlos Fajardo, Daniel Acosta, Iran do Espírito Santo, Julio Plaza, Lucia Koch, Monica Nador, Nelson Leirner and Regina Silveira to occupy Paço das Artes. Paço was intended to be a new public space for contemporary art in São Paulo, but the building where it is located was never finished as a whole, and part of the finished construction site was used for the exhibition. The chaotic architecture evinced the tension between the ideal space for art versus the real possibilities for the local economy to invest in experimental culture (fig. 5). Limits were regarded as opportunities for creativity.

Since the late 1990s, groups of artists assumed collective identities as performers in urban interventions and as participants in museum or gallery shows. This dual role – the possibility of operating on the streets and in institutions – indicated the concern for public culture. But

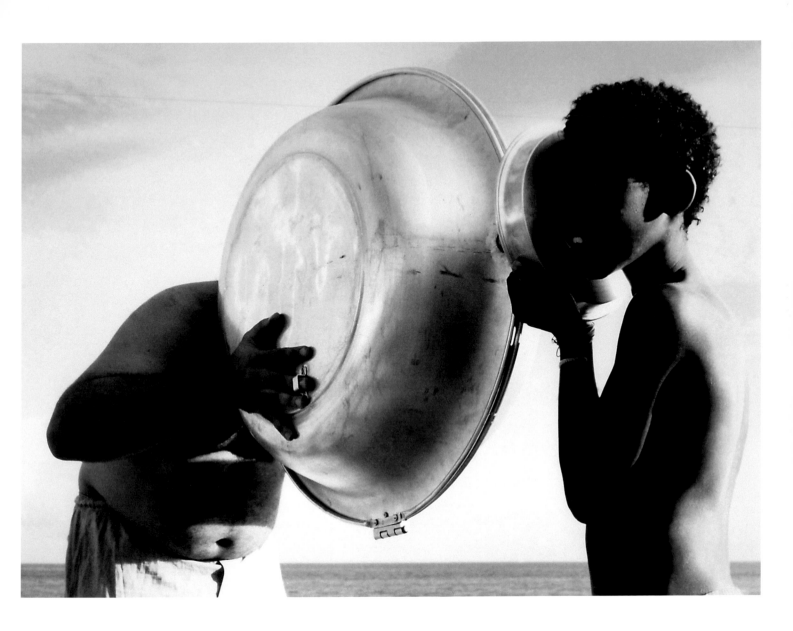

FIG 4: Marepe's 'Cabeça Acústica' [Acoustic Head] performance at Barra Beach, Salvador in 1995.

95

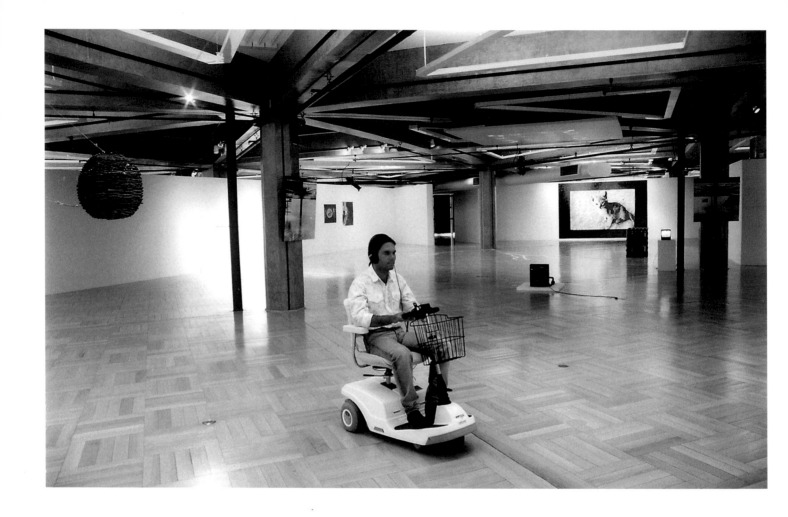

Installation view of the group show *Ao Cubo* in Paço das Artes, São Paulo in 1997.

working with institutions eventually damaged the floating identity of such groups. In 2001, the Museum of Modern Art of São Paulo organised the *Panorama of Brazilian Art*, a periodic exhibition that went back to 1969. The first *Panorama* of the new millennium focused on groups such as Camelo from Recife, Clube da Lata from Porto Alegre and Mico from São Paulo, and on small art spaces such as Alpendre in Fortaleza, Torreão in Porto Alegre and Agora-Capacete in Rio. It would appear that this relationship with the museum led to the dissolution of Mico and Clube da Lata, as their members were not ready to claim authorship of works. Nevertheless, this crisis was also the beginning of new groups (which included former members) such as Contra-File in São Paulo, which had a more mature vision of art politics.

Urban intervention was not seen as being opposed to public institutions, but as a way of increasing awareness of contemporary culture in cities. In 2001, the Centro Cultural Mariantonia of the University of São Paulo and the Faculty of Arts of Fundação Armando Alvares Penteado organised a series of interventions in Vila Buarque, their immediate environs in downtown São

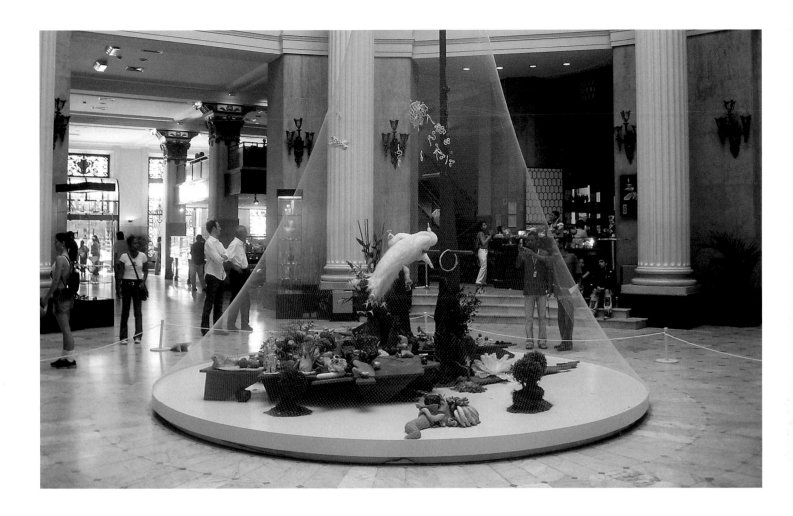

FIG 6: Laura Lima installation with caged birds in the *Barroco* exhibition at the Centro Cultural Banco do Brasil, São Paulo in 2005..

Paulo. Independent groups, a public centre and a private faculty joined in a collective project to improve a common environment.

As private investment grew in the area of culture, old buildings were restored and adapted for exhibitions. Contemporary artists faced new architectonic challenges for creating site-specific works. Banco do Brasil installed large cultural centres in two of its oldest bank agencies, one in downtown Rio, the other in downtown São Paulo. Both buildings have *belle-époque* architecture, with a central hall illuminated by a glass roof; where artists such as Laura Lima, Regina Silveira and Nuno Ramos have installed pieces specific to the scale and grandeur of the architecture (fig. 6). These sites are currently helping to change the character of their urban surroundings, as visitors are now going downtown at weekends and at night.

Historical buildings also benefited from the change in cultural finance, allowing private investment in state institutions. In Rio, the former colonial palace, Paço Imperial, has been dedicated to contemporary art since 1985. We can add Plataforma Contemporânea of the Museu Imperial in

FIG 7: Installation view of Ana Maria Tavares' 'Porto Pampulha' at the Museu de Arte da Pampulha, Belo Horizonte in 1997.

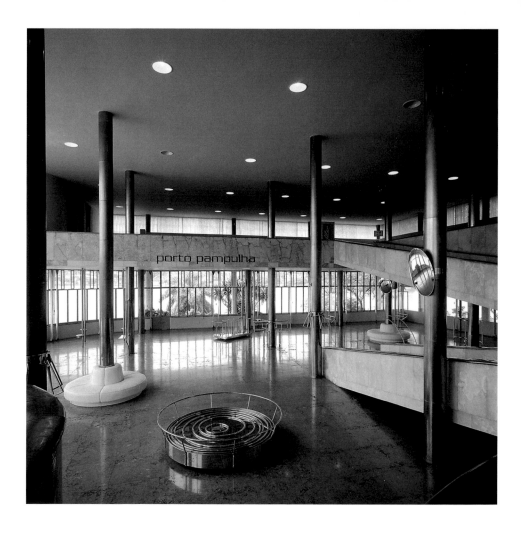

Petropólis, Museu de Arte Moderna in Recife, Centro Cultural São Francisco in João Pessoa, Casa das Onze Janelas and Palacio Landi in Belém. The 1990s set new conditions for Brazilian culture within the global economy. Though there was not the idea of revolutionary activity that marked the 'Nova Objetividade Brasileira' of the 60s, the naive optimism of the 80s was now substituted by a more realistic commitment to building a real and sustained network of institutions, both public and private, occupied by individual artists and collective groups (fig. 7).

In the mid 90s, the participation of commercial galleries in art fairs of contemporary and modern art started to increase. Even if this has not put Brazilian art in a key position in the international market, it has generated local awareness of the speed of the international circuit.[9] The Camargo Vilaça Gallery in São Paulo had a major role in this change, for its director Marcantonio Vilaça started to participate in fairs at Basel, Buenos Aires, Chicago, Madrid, London and New York in 1992. Before that, only Luisa Strina's and Thomas Cohn's galleries held a similar position,

9 See A. Fialho, 'Mercado das artes: global e desigual', in *Tropico* at www.uol.com.br/tropico.

FIG 8: Iran do Espírito Santo's 'Untitled [Unfolded]' from his solo show at Galeria Fortes Vilaça in 2004.

representing artists such as Antonio Dias and Cildo Meireles. By the time of Vilaça's death in 2000, Brito Cimino, Casa Triângulo, Raquel Arnaud, Marilia Razuk, Baro Sena, and Nara Roesler were all participating in fairs abroad. Vilaça also showed at events such as the Venice Biennale, making contacts with curators and artists in order to bring them to his gallery and sending artists he represented abroad. Iran do Espírito Santo, Jac Leirner, Nuno Ramos, Valeska Soares and Vik Muniz are some of the artists who showed regularly at Camargo Vilaça and in Europe and the United States. The logic of international art diplomacy, mixing fairs and biennials, was soon familiar to the younger artists who are now known to the gallery-going public in Brazil.

International prices afford competition, and thus the revenue from art fairs could sometimes rival that derived from the regular market in Brazil. More expensive works could thus be produced in private spaces, making possible the kind of project that, previously, only big public events such as the Bienal or Arte-Cidade, would have been able to support (fig. 8).

FIG 9: 'Acampamento dos Anjos' [Camp of Angels], 2005 by Eduardo Srur – a *fachada* project on the front of Galeria Vermelho.

FIG 10: View of Niemeyer's Museu de Arte Contemporânea de Niterói, Rio de Janeiro.

In the last five years, new galleries of contemporary art have appeared in São Paulo, Rio, Curitiba, Recife, Salvador, Goiania, and, in 2005, the first Brazilian art fair of contemporary and modern works took place in the ground floor of the Bienal de São Paulo building. Of these new galleries, four – Vermelho in São Paulo, A-Gentil Carioca in Rio, Ybakatu in Curitiba and Mariana Moura in Recife – opened with experimental projects that interfered with the structure of their gallery buildings and sometimes with the surrounding areas (fig. 9). Vermelho also organised a performance journey during a Saturday in 2003, when artists would perform both inside the commercial space and around it, connecting the artistic action to a wider urban context. In 2005, A-Gentil Carioca produced a collective walk from its building to the National Museum of Fine Art, both in downtown Rio, in order to deliver a closed box containing works by Franklin Cassaro; the ownership of the works was the subject of a legal dispute between the artist and his former gallery, but the Museum accepted the donation of the contested works all the same.

The national importance of contemporary art benefits from the international presence of Brazilian works in foreign shows and collections, and the work of private galleries has therefore been acknowledged as a means of representing public interests. The situation has, in turn, contributed to the construction of new museums of contemporary art. Oscar Niemeyer is once again the main architect involved in the conception of spaces such as Museu de Arte Contemporanea de Niterói, Museu Oscar Niemeyer in Curitiba, and Museu de Arte Contemporanea de Goiania (to be inaugurated in 2006). Private institutions have also been built, such as Instituto Tomie Ohtake in São Paulo by the architect Ruy Ohtake and Fundação Ibere Camargo in Porto Alegre by Portuguese architect Alvaro Siza (to be inaugurated in 2006). These projects – and especially Niemeyer's – create specific challenges for artists and curators, as he now denies the neutrality of the art space, contrary to the main characteristic of his Bienal building in São Paulo (fig. 10).

The garden pavilions of Parque do Ibirapuera, one of which houses the Bienal de São Paulo, were designed by Niemeyer in 1954 as part of the celebrations for the 400th anniversary of São Paulo, the strongest industrial state in Brazil. The main lines of the park were laid out by Burle Marx. Niemeyer and Burle Marx had worked together on the first modernist State building in Brazil between 1937 and 1943, and again in 1942 for the Pampulha in Belo Horizonte; an urban complex around a lake consisting of St Francis' church, a ballroom pavilion and a casino (now the Museu de Arte da Pampulha). The transparency of modernist buildings, which incorporated the landscape around them, was achieved by using glass panes and the slight, elegant concrete columns called *pilotis*. In comparison to the colourful tropical gardens seen through the windows, national reality was in fact no paradise. State Modernism, shaped by Niemeyer and Burle Marx, would be the official Brazilian style during most of the twentieth century for governments that did not actually change social inequality. This situation was obvious to Max Bill in 1954:

In a street here in São Paulo I have seen under construction a building in which *pilotis* construction is carried to extremes one would have supposed impossible. There I saw some shocking things, modern architecture sunk to the depths, a riot of anti-social waste, lacking any sense of responsibility toward either the business occupant or his customers.[10]

10 K. Frampton, *Modern Architecture*, London: Thames and Hudson, 1994, 3rd edition, p. 257.

However, the structural desire for communication with the outside constituted the technique of *pilotis* and glass walls. Therefore acquaintance with the international agenda at the beginning of the Cold War was made within the transparent galleries of the Museu de Arte Moderna do Rio and the Bienal do Museu de Arte Moderna de São Paulo, which offered a simultaneous view of the closed space of art and of our environment.

The brutal interruption of a fertile national self-critique by the dictatorship changed the means of experimentation, turning them into survival strategies within a counter-culture. Yet the institutions created by State modernists were still important, and the refusal to participate in the Bienal de São Paulo from 1969 until 1980 was a means of protest against the government.[11]

The revived practice of debate amongst artists, curators and the public has benefited from the recent expansion in the number of institutions. In the last twenty-five years, a Brazilian network of galleries, contemporary spaces and experimental museums has grown in line with a critical art made by artists committed to exploring the tensions within culture, in a country where social conditions are still in conflict under democracy.

FELIPE CHAIMOVICH

11 F. Alambert and P. Canhete, *As Bienais de São Paulo*, São Paulo; Boitempo, 2004, pp. 124–154.

MICHAEL ASBURY was born in Tesesopolis, Rio de Janeiro, the son of British missionaries, and was educated in Brazil until the age of twenty. He is currently a Research Fellow at the University of the Arts, London and core member of Transnational Art Identity and Nation (TrAIN). He has published widely and has curated exhibitions, including *Antonio Manuel* at the Pharos Trust in Nicosia, Cyprus in 2005.

REGINA TEIXEIRA DE BARROS has been a teacher of Art History at the Faculdade Santa Marcelina since 2002 and curator at the Pinacoteca do Estado de São Paulo since 2003, having previously been General-Secretary of the Leonilson Project (1995–96) and assistant to the curator of the 22nd International Bienal de São Paulo (1993–94). She has curated many exhibitions and has written or edited texts for numerous publications, including *Henry Moore: Uma Retrospectiva*.

FELIPE CHAIMOVICH holds a PhD in Philosophy from the Universidade de São Paulo and is art critic for *Folha de São Paulo*. He was curator of the 29th *Panorama da Arte Brasileira* (2005) at the Museum of Modern Art in São Paulo and was author of the monograph *Iran do Espírito Santo* (São Paulo: Cosac & Naify, 2000).

CACILDA TEIXEIRA DA COSTA holds a PhD in Art History from the University of São Paulo. She has worked as a freelance curator of such exhibitions as *Wesley Duke Lee: Retrospective* at MASP and *Approximations to the Pop Spirit* at MAM, São Paulo and has been an adviser to number of television programmes. She is author of many publications, including most recently *Art in Brazil 1950–2000 Movements and Means* (2004).

Bibliography

KEY BOOKS ON EXHIBITED ARTISTS

Andriesse, P., *Luisa Lambri*, Amsterdam: Galerie Paul Andriesse, 2005

Belluzzo, A. M., *Waldemar Cordeiro: uma aventura da razão*, São Paulo: Museu de Arte Contemporânea da Universidade de São Paulo, 1986

Brecheret Pellegrini, S., *Brecheret*, São Paulo: Almed Editora e Livraria Ltda, 2000

Brecheret Pellegrini, S., *Victor Brecheret 1894–1955*, São Paulo: Editora Revan, 2001

Camillo, L., *Works: Ducha*, London: Gasworks Gallery, 2003

Canongia, L., *Artur Barrio*, São Paulo: Modo Edicoes, 2002

Canongia, L., *Jac Leirner: ad infinitum*, Rio de Janeiro: Centro Cultural Banco do Brasil, 2002

Cauteren, P. van, 'Paulo Climachauska: Drowning by Numbers' in *26a Bienal de São Paulo: representações nacionais: artistas convidados*, (exhibition catalogue), São Paulo; Fundação Bienal, 2004

Chaimovich, F., *Iran do Espírito Santo*, São Paulo: Cosac Naify, 2000

Chiarelli, T., *Nelson Leirner: arte e não arte*, São Paulo: Galeria Brito Cimino and Grupo Takano, 2002

Curry, D., *Franz Weissmann: uma retrospectiva* (exhibition catalogue), Rio de Janeiro: Centro Cultural do Banco do Brasil and Museu de Arte Moderna & São Paulo; Museu de Arte Moderna, 1998

Cypriano, F., *Sob o Signo da Transição*, Brasília: Arte 21 – Escritório de Arte e Projetos Culturais, 2004

Drutt, M., *Luisa Lambri: Locations* (exhibition catalogue), Houston: The Menil Collection, 2004

Garcia dos Santos, L., 'Rubens Mano: An Art Space and its Production' in *Parachute*, no. 116 (São Paulo), Montréal: Parachute, October 2004

Garcia dos Santos, L., *Rubens Mano*, São Paulo: Galeria Casa Triângulo, 2002

Herkenhoff, P. & Molder, J., *Antonio Dias*, São Paulo: Cosac & Naify, 1999

Herkenhoff, P., *Cildo Meireles*, London: Phaidon Press, 1999

Herkenhoff, P., Mosquera, G., Cameron, D., *Cildo Meireles*, São Paulo: Cosac & Naify, 2000

Lagnado, L., 'Angela Detanico and Rafael Lain: The Hackers of Representation Systems' in *26a Bienal de São Paulo: representações nacionais: artistas convidados*, (exhibition catalogue), São Paulo; Fundação Bienal, 2004

Lagnado, L., 'Angela Detanico et Rafael Lain: Du Langage Partout', in *Parachute*, no. 118 (Design), Montréal: Parachute, April 2005 (French)

Mattos, C. V. de, *Entre quadros e esculturas: Wesley e os fundadores da Escola Brasil*, São Paulo: Discurso Editorial, 1997 (Portuguese)

Molder, J., *Antonio Dias: trabalhas: 1965–1999*, São Paulo: Cosac & Naify, 1999

Monachesi, J., *Eduardo Srur: Acampamento dos Anjos*, São Paulo: 2005

Niemeyer, O., *My architecture: Oscar Niemeyer*, Rio de Janeiro: Sindicato Nacional dos Editores de Livros, 2000

Pedrosa, A., (ed.), *Nelson Leirner and Iran do Espírito Santo: 48. Biennale di Venezia – Padiglone Brasile*, São Paulo: Fundação Bienal, 1999

Ramiro, M., 'Grupo 3NÓS3: The Outside Expands' in *Parachute*, no. 116 (São Paulo), Montréal: Parachute, October 2004

Salvaing, M., *Oscar Niemeyer*, New York: Assouline Publishing, 2004

Salzstein, S., *Antonio Dias: O País Inventado* (exhibition catalogue), São Paulo: MAM & Rio de Janeiro: MAM, 2002

Severo, H., *Antonio Manuel*, Rio de Janeiro: Centro de Arte Hélio Oiticica, 1997

Staber, M., *Max Bill*, London: Methuen, 1964

GENERAL READING

Ades, D., *Art in Latin America: the modern era 1820–1990*, New Haven and London: Yale University Press, 1989

Aguilar, N., & Bowron, A. (orgs.), *Experiment/Experiência: Art in Brazil 1958–2000* (exhibition catalogue), Oxford: MOMA, 2001

Alambert, F., *As Bienais de São Paulo: da era do Museu à era dos curadores (1951–2001)*, São Paulo: Boitempo, 2004 (Portuguese)

Alves, P., (ed.), *Coleção MAC*, São Paulo: Museu de Arte Contemporânea da Universidade de São Paulo, 2003

Amaral, A., (ed.), *Mario Pedrosa: Dos Murais de Portinari aos Espaços de Brasilia*, Série Debates 170, São Paulo: Editora Perspectiva, 1981 (Portuguese)

Amaral, A., (ed.), *Projeto Construtivo Brasileiro na Arte (1950–1962)* (exhibition catalogue), Rio de Janeiro and São Paulo: Museu de Arte Moderna do Rio de Janeiro, MEC–FUNARTE & Secretaria da Cultura, Ciência e Tecnologia do Estado de São Paulo, Pinacotéca do Estado, 1977 (Portuguese)

Amaral, A., *Arte Para Que? A preocupação Social na Arte Brasileira 1930–1970. Subsidio para uma História Social da Arte no Brasil*, São Paulo: Nobel, 1984 (Portuguese)

Amarante, L., *As Bienais de São Paulo*, São Paulo: BFB, 1989 (Portuguese)

Andreoli, E. & Forty, A., (eds.), *Brazil's Modern Architecture*, London: Phaidon Press Limited, 2004

Asbury, M., 'Neoconcretism and Minimalism: On Ferreira Gullar's Theory of the Non-Object', in Mercer, K., (ed.), *Cosmopolitan Modernisms*, Cambridge, Mass. & London: The MIT Press and InIVA, 2005

Asbury, M., 'Tracing Hybrid Strategies in Brazilian Modern Art', in Harris, J., (ed.), *Critical Perspectives on Contemporary Painting*, Critical Forum Series, Liverpool: Tate Gallery Liverpool and University of Liverpool Press, 2004

Basbaum, R., (ed.), *Arte Contemporânea Brasileira: Textos, Dicções, Ficções, Estratégias*, Rio de Janeiro: Contra Capa, Coleção N-Imagem, 2001 (Portuguese)

Basbaum, R., Reis, R. & Resende, R., *Panorama da Arte Brasileira 2001*, São Paulo: Museu de Arte Moderna, 2001

Basualdo, C., (ed.), *Tropicália: A Revolution in Brazilian Culture (1967–1972)* (exhibition catalogue), São Paulo: Cosac Naify with MCA, Chicago, The Bronx Museum of the Arts, New York, & Gabinete Cultura, São Paulo, 2005

Blazwick, I., (ed.), *Century City: art and culture in the modern metropolis*, London: Tate Gallery Publishing Limited, 2001

Breitwieser, S., *Vivências/lebenserfahrung/life experience*, Vienna: Generali Foundation, 2000

Brett, G., *Brasil Experimental – arte/vida: proposições e paradoxos*, Rio de Janeiro: Contra Capa, Coleção N-Imagem, 2005 (Portuguese)

Brett, G., *Transcontinental: Nine Latin American Artists* (exhibition catalogue), London: Verso, Birmingham: Ikon & Manchester: Cornerhouse, 1990

Brillembourg, C., *Latin American architecture 1929–1960*, New York: Monacelli Press, 2004

Brito, M. da S., *História do Modernismo Brasileiro: Antecedentes da Semana de Arte Moderna*, Rio de Janeiro: Civilização Brasileira, 1978 (Portuguese)

Brito, R., *Neoconcretismo: vértice e ruptura do projeto construtivo brasileiro*, São Paulo: Cosac & Naify, 1999 (Portuguese)

Cocchiarale, F. & Geiger, A. B., (eds.), *Abstracionismo Geométrico e Informal: a vanguarda brasileira nos anos cinquenta*, Instituto Nacional de Artes Plasticas, Rio de Janeiro: FUNARTE, 1987 (Portuguese)

Duarte, P. S., *The 60s: Transformations of art in Brazil* (exhibition catalogue), Rio de Janeiro; Campos Gerais, 1998

Dunn, C., *Brutality Garden: Tropicália and the emergence of a Brazilian counter culture*, North Carolina: University of North Carolina Press, 2001

Farias, A., *Retrospectiva Nelson Leirner*, São Paulo: Paço das Artes, 1994

Frampton, K., *Modern Architecture: A Critical Theory*, London: Thames & Hudson, 1992 (3rd ed., 1st ed. 1980)

Freire, C., *ARTE conceitual e conceitualismos: anos 70 no acervo do MAC USP*, São Paulo: Museu de Arte Contemporânea da Universidade de São Paulo, 2000 (Portuguese)

Gomes Machado, L., (artistic director), *I Bienal do Museu de Arte Moderna de São Paulo: catalogo* (exhibition catalogue), São Paulo: Museu de Arte Moderna, 1951 (Portuguese)

Gullar, F., 'Teoria do Não-Objeto', *Jornal do Brasil* (Suplemento Dominical), Rio de Janeiro: 19–20 December 1959 (Portuguese), translated to English in Mercer (2005)

Herkenhoff, P., (org.), *Antropofagia: XXIV Bienal de São Paulo* (exhibition catalogue), São Paulo: Fundação Bienal de São Paulo, 1988

Lunn, F., (org.), *Vivências: Dialogues Between the Works of Brazilian Artists from the 1960s to 2002* (exhibition catalogue), Walsall: The New Art Gallery, 2002

Machado, L. G., *I Bienal de São Paulo* (exhibition catalogue), São Paulo: Museu de Arte Moderna, 1951 (Portuguese)

Milliet, S., (artistic director), *II Bienal do Museu de Arte Moderna de São Paulo: catalogo geral* (exhibition catalogue), São Paulo: Museu de Arte Moderna, 1953 (Portuguese)

Milliet, S., (artistic director), *IV Bienal do Museu de Arte Moderna de São Paulo: catalogo geral* (exhibition catalogue), São Paulo: Museu de Arte Moderna, 1957 (Portuguese)

Moraes, A. de, *Trajectory/trajectories*, Rio de Janeiro: Gabinete de Arte Raquel Arnaud, 2005 (Portuguese)

Mosquera, G., *Panorama da Arte Brasileira 2003: (desarrumado) 19 desarranjos*, São Paulo: Museu de Arte Moderna, 2003

Ramirez, M. C. & Olea, H., (eds.), *Inverted Utopias: Avant Garde Art in Latin America* (exhibition catalogue), New Haven and London: Yale University Press (with The Museum of Fine Arts), Houston, 2004

Rogers, B., (ed.), *Britain and the São Paulo Bienal 1951–1991*, São Paulo: The British Council, 1991

Schwartz, J., (org.), *Da Antropofagia a Brasília: Brasil 1920–1950* (exhibition catalogue), Valência: IVAM, São Paulo: FAAP & Cosac Naify, 2002

Sullivan, E. J., *Brazil: body and soul*, New York: Guggenheim Museum, 2001

Sullivan, Edward J., *Latin American art in the twentieth century*, London: Phaidon Press, 1996

Teixiera da Costa, C., *Aproximações do Espírito Pop – 1963–1968: Waldemar Cordeiro, Antonio Dias, Wesley Duke Lee, Nelson Leirner* (exhibition catalogue), São Paulo: MAM SP, 2003

Teles, G. M., *Vanguarda Européia e Modernismo Brasileiro*, Petrópolis: Vozes, 1997, (13th ed., 1st ed. 1972) (Portuguese)

Zanini, W., 'Arte contemporânea' in *História general da arte no Brasil*, São Paulo: Instituto Walter Moreira Salles, 1983, v. 2

Zelevansky, L., (ed.), *Beyond Geometry: Experiments in Form, 1940s–70s*, Cambridge, Mass. & London: The MIT Press with LACMA, Los Angeles, 2004

All texts are available in English unless stated otherwise.

Text and picture credits

All texts and images of art works are reproduced with permission from each artist. Additional credits are due as follows:

Stephen Feeke: Introduction
Fig. 1: courtesy Arquivo Histórico Wanda Svevo, Fundação Bienal de São Paulo; fig. 2: Courtesy Galeria Brito Cimino; fig. 3: Commissioned by the British Council for the 26th Bienal de São Paulo, 2004. Photo: Mike Nelson courtesy Matt's Gallery, London; fig. 4: Courtesy Millan Antonio; fig. 5: Collection of Museu de Arte Moderna de São Paulo. Photo: (duplicate) Romulo Fialdini.

Artists' pages and catalogue of exhibits:
Cat. 1: text first published in the catalogue *Zeitprobleme in der Schweizer Malerei und Plastik*, 1936 and subsequently revised for the catalogue *Zürcher Konkrete Kunst*, 1949. Taken from *Max Bill* (exhibition catalogue), Buffalo: Albright-Knox Art Gallery, 1974, p. 47, © Max, Binia + Jakob Bill Foundation, CH – Adligenswil. Photo: Museu de Arte Contemporânea da Universidade de São Paulo © DACS, 2005; cat. 2: photo Museu de Arte Contemporânea da Universidade de São Paulo courtesy Sandra Brecheret Pellegrini/Fundação Escultor Victor Brecheret, São Paulo; cat. 3: statement given by Franz Weissmann to Angelica de Moraes in 'I have never known how to copy anything, only create', *Caderno 2, O Estado de São Paulo*, 20 May 1995, p. 6. © Franz Weissmann Estate, Rio de Janeiro. Photo: Wilton Montenegro © Franz Weissmann Estate, Rio de Janeiro; cats. 4 & 31: photos courtesy Casa Triângulo, São Paulo; cat. 5: photos courtesy Galeria Vermelho, São Paulo; cat. 7: 'The Poetics of Space: A conversation between Matthew Drutt and Luisa Lambri' in *Luisa Lambri: Locations* (exhibition catalogue), Houston: The Menil Collection, 2004, p. 61, © 2004 Menil Foundation, Inc.; cat. 9: photos courtesy Galeria Millan Antonio, São Paulo; cat. 10: first published in *Collective Creativity* (exhibition catalogue), Frankfurt am Main: Revolver: Archiv für aktuelle Kunst & Kassel: Kunsthalle Fridericianum, 2005, pp. 254–55; cats. 12 & 28: photo courtesy Galeria Fortes Vilaça, Sao Paulo; cat. 13: photos courtesy Nelson Leirner, Biblioteca Museu de Arte Moderna de São Paulo and Galeria Brito Cimino, São Paulo; cats. 14–16 & 27: 1970/89. *Cildo Meireles*, IVAM Centre del Carme, Valencia, 1995, pp. 175–176. Revised 1999, *Cildo Meireles*, London: Phaidon, 1999, pp. 108–9. Photos: Courtesy Galerie Lelong, New York & Luisa Strina, São Paulo. Cat. 17: photo by Roberto Cecato. Cat. 18: Photo by Vicente de Mello. Cats. 21–23: extract from an interview with Lúcia Carneiro and Ileana Pradilla, *Palavra do artista*, Rio de Janeiro: Lacerda Ed., 1999, p. 80. Cat. 24: extract from 'arte concreta semântica' [semantic concrete art] published in *Waldemar Cordeiro* (exhibition catalogue), São Paulo: Galeria Atrium, 1964, p. 2, using the artist's original lowercase letters reproduced with permission from the Familia Cordeiro and taken from Waldemar Cordeiro CD © 2001 Analivia Cordeiro/Galeria Brito Cimino, São Paulo. Photo: Familia Cordeiro; cat. 29: photo courtesy Galeria Millan Antonio, São Paulo; cat. 30: stills courtesy Galeria Vermelho, São Paulo. Texts accompanying cats. 2–5, 8, 11, 13, 17–20, 21–24 translated by Juliet Attwater.

Michael Asbury:
Figs. 1 & 6: courtesy Arquivo Histórico Wanda Svevo, Fundação Bienal de São Paulo; figs. 2 & 4: courtesy Sandra Brecheret Pellegrini/Fundação Escultor Victor Brecheret. Photo: Roberlandas O. Coelho; fig. 5: Acervo Burle Marx, Rio de Janeiro © Haruyoshi Ono; fig. 8: Associação Cultural 'O Mundo de Lygia Clark', Rio de Janeiro © ADAGP, Paris and DACS, London 2005.

Cacilda Teixeira da Costa:
Fig. 1: Arquivo Agência O Globo/File, São Paulo; figs. 2 & 4: Photos by Vicente de Mello; fig. 3: Collection of Pinacoteca do Estado, São Paulo; fig. 5: Família Cordeiro; cat. 13: courtesy Biblioteca Museu de Arte Moderna de São Paulo and Galeria Brito Cimino, São Paulo. Text translated by Juliet Attwater.

Felipe Chaimovich:
Figs. 1–3 all courtesy Museu de Arte Moderna de São Paulo; fig. 4: Courtesy Galeria Luisa Strina, São Paulo, photo by Marcondes Dourado; figs. 5 & 7: Courtesy Galeria Brito Cimino, photo [5] by Ricard Akagawa & photo [7] by Eduardo Brandão; fig. 6: Courtesy A-Gentil Carioca, Rio de Janeiro; fig. 8: Courtesy Galeria Fortes Vilaça, São Paulo, photo by Eduardo Ortega; fig. 9: Courtesy Galeria Vermelho, São Paulo; fig. 10: Paul Meurs, Urban Fabric, Schiedam.

Cover image:
Exhibition logo by Detanico Lain in 'Utopia', 2001 (cat. 9).

Acknowledgements

The Henry Moore Institute is grateful to the artists, galleries and collectors who have generously made work available for this exhibition. Additional thanks from Stephen Feeke are due to the following people for their kind assistance:

Elza Ajzenberg, Jane Alison, Margarida Sant'Anna, Florence Antonio, Marcelo Araujo, Gill Armstrong, Michael Asbury, Juliet Attwater, Orianna Baddeley, Tanya Barson, Regina Teixeira de Barros, Anita Feldman Bennett, Joanne Bernstein, Leslie Bethell, Fiona Boundy, Márcio Botner, Nelson Brissac, Luciana Brito, Waltercio Caldas, Kátia Canton, Lauro Cavalcanti, Rejane Cintrão, Danielle Col, Cacilda Teixeira da Costa, Rochelle Costi, Penelope Curtis, Eugenia Gorini Esmeraldo, Eliana Finkelstein, Alexandre Gabriel, Ann Gallagher, John Gledson, Ana Maria Hoffmann, Nelson Leirner, Tim Llewellyn, Ascânio MMM, Ana Magalhães, Dalton Maziero, Lucia de Meira Lima, Tânia Mills, David Mitchinson, Ana Paula Montes, Juliana Moreira, Ernesto Neto, Fernando Ortega, Malu Penna, Ricardo Resende, Paulo Roberto, Mônica S. de Carvalho, Gabriella Salgado, Maria Rossi Samora, Marcelo Spinelli, Luisa Strina, Ellen Tait, Elida Tessler, Pieter Tjabbes, Luiz Guilherme Vergara, Nigel Walsh, Victoria Walsh, Waltraud Weissmann, Richard Williams, Isobel Whitelegg, Julie Rodrigues Widholm, Mike Winter.

Published to accompany the exhibition
Espaço Aberto/Espaço Fechado
Sites for Sculpture in Modern Brazil

5 February–16 April 2006
at the Henry Moore Institute

Curated by Stephen Feeke
with the assistance of Regina Teixeira de Barros and Michael Asbury

Administrative support by Ellen Tait
Installation supervised by Matthew Crawley

Catalogue prepared and published in Great Britain
by the Henry Moore Institute
74 The Headrow
Leeds
LS1 3AH

Catalogue edited by Penelope Curtis and Stephen Feeke
Catalogue co-ordinated by Stephen Feeke
Picture research by Stephen Feeke and Gill Armstrong

Translations by Juliet Attwater

Text © the authors and The Henry Moore Foundation

ISBN 1 900081 99 7

Designed and typeset by Robert Johnston
Printed by Beith Printing Co. Ltd., Glasgow

The Henry Moore Institute is part of the Henry Moore Foundation
www.henry-moore-fdn.co.uk/hmi

Distribution by Cornerhouse Publications
www.cornerhouse.org/publications